Guidebook for an Armchair Pilgrimage

Guidebook for an Armchair Pilgrimage

TEXT : **Phil Smith** & **Tony Whitehead**

PHOTOGRAPHY & DESIGN : **John Schott**

Published in this First Edition in 2019 by:

Triarchy Press
Axminster, England

info@triarchypress.net
www.triarchypress.net

Cover image: John Schott

Print ISBN: 978-1-911193-59-3
e-Pub ISBN: 978-1-911193-60-9

Printed by Gomer Press, Llandysul, Ceredigion

When you are no longer loved by those who loved you, or when you no longer love those you once did, when you are distracted, when you cannot find your certainty or uncertainty, when you can no longer remember silence, when you have lost your way, or when you are simply ready…sit down and begin this journey to another part of yourself and find difference and change on your way to the unknown destination. What is most real is what you have still to discover.

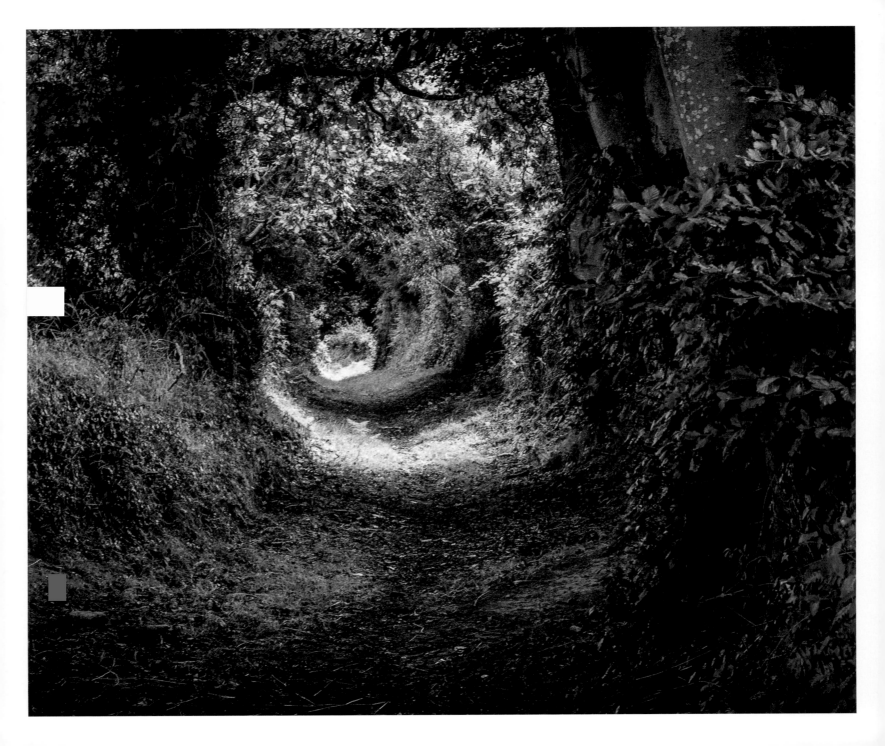

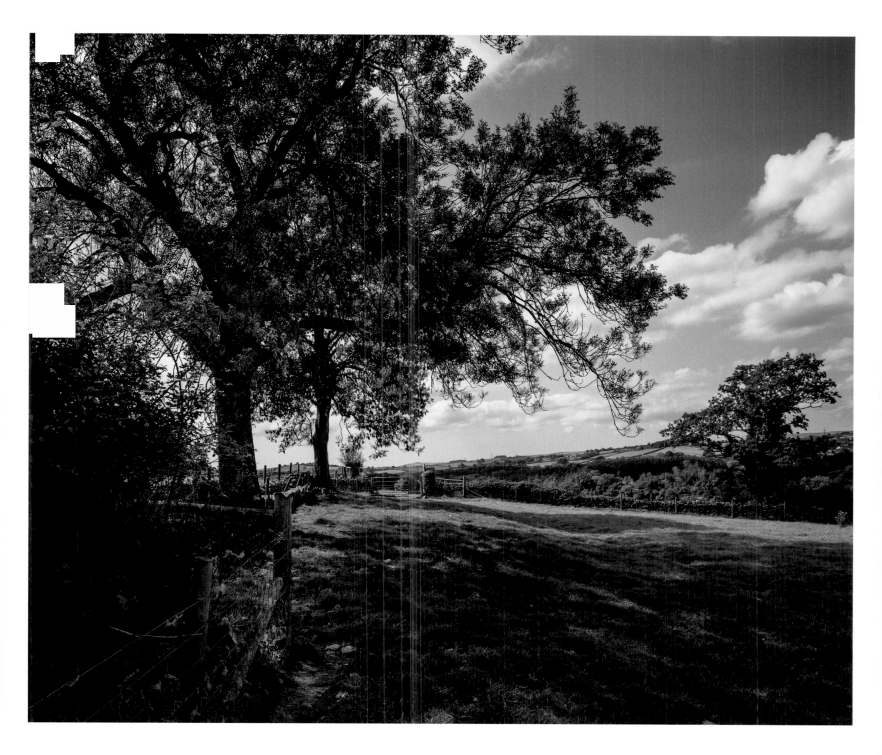

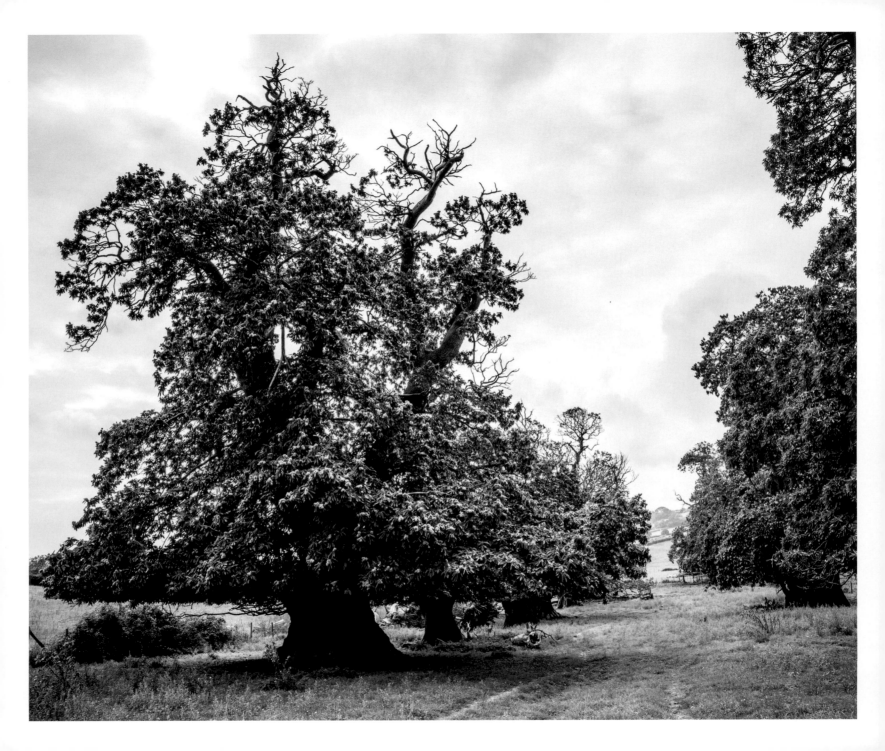

How to Use this Book

THE JOURNEY IS DIVIDED into nineteen 'days', each comprising images and text. We invite you to read the book one 'day' at a time. You will find your own pace for this; you may pause for a few seconds or a few minutes after each 'day' and then press on, or you may put the book aside for twenty-four hours between each mini-journey. You may read the day's text straight to the end and then turn back to dwell on certain phrases or to lose yourself for a while in the images. Or you may go gently, a phrase or a sentence at a time; loitering around some punctuation or lingering over a metaphor. Some 'days' may take you longer to assimilate and absorb than others; set your own pace.

The particular selection of images, feelings and ideas from the original journey are offers, starting points or junctions on a journey into your own thoughts and feelings. We wish you as safe and as brightly illuminating a journey as we were fortunate to take.

Introduction

THE JOURNEY YOU ARE ABOUT TO TAKE is one that follows a path through your own imagination, prompted by images and narratives from an actual journey that we, the authors, walked over many days. A journey that wandered through real landscapes with plentiful encounters, discoveries and stories in which real and mystery were always close companions.

This journey led us along lanes and around hills, into caves and down to the coast; it was punctuated by remarkable coincidences and the uncovering of spider-web connections of people and ideas. It was turned from wandering into pilgrimage by the guidance of the landscape. We arrived again and again at what we assumed would be a final 'shrine', only to be drawn onwards and inwards towards another kind of finality, and then another and another; rather than reaching a destination, the pilgrimage was repeatedly reborn inside us, until its most recent rebirth in this book.

In these pages we have recreated our spontaneous pilgrimage as a series of short journeys; brief routes for you, the reader and armchair pilgrim, to follow inside your own imaginations, finding your own turnings, side roads and alleys. Many of the places along that original journey were private or restricted areas; there was an occasional trespass, access was negotiated to some places, often on condition that locations were not revealed.

So this is not a guidebook to making a journey in any physical or geographical landscape. Instead, it follows the example of Felix Fabri, a fifteenth-century monk, who drew upon his visits to Jerusalem to write a handbook to be used by nuns for a virtual pilgrimage to that city, travelling in their own imaginations, while physically confined to their religious houses.

Guidebook for an Armchair Pilgrimage invites you to make your own virtual pilgrimage using the photographic images and textual descriptions here as maps to guide your thoughts.

DAY 1

The Dunes and the Importance of the Particular

RELAX IN YOUR SEAT. Allow the train to take you along the water's edge to the beginning point of your walking pilgrimage. The rails you ride on were washed away recently by storms, and then rebuilt. Today, however, the sea is calm.

When the train pulls into the platform, step off the train. Hidden behind the platform is a broken machine; a mechanised fortune teller – the 'voice of truth' – discarded from the nearby arcade of slot machines. Propped against the side of a building, its mouth is silent, its pronouncements have ceased; any truths you find today will be your own.

Make your way through the holiday caravans and fairground 'rides', then beyond the shops to the beach and follow the water's edge. After a while you will leave the bathers behind as you head towards the solitude of the dunes at the far end of a long spit of land that divides the sea from an estuary.

Once at the top of the dunes, sit and look out across the flat sea and contemplate the illusion that what is true of one place is necessarily true of any other. Contemplate the troubles inflicted when we find a truth in one place and seek to impose that same truth elsewhere. Then let the troubles go.

Sink into the dunes a little. Feel some itchy grains of sand as they inveigle their way into your clothes and rub against your skin. Feel them individually; focus into tiny points of attention around the irritation. Then let them go too.

Let your focus spread outwards from the centre of your chest towards the horizon, skimming like an expertly thrown stone, glancing lightly across the water's surface, barely leaving a mark. Hold that for a good long while. Then let that go.

The Sea and the Movement of All Things

Maybe our sometime tendency to apply what we learn about one thing to all things is an echo of a time forty to fifty thousand years ago when our 'chapel' mind of specialisms became a 'cathedral' mind and we could put all kinds of knowledge together. For a moment, reverse the evolutionary process: cherish the contents of imagining chapel, counting chapel, desiring chapel. Acknowledge the agency of separate things – sand crumbling, marram grass pricking – and fascinating ideas. Consider how simple philosophies and bold fantasies have changed worlds, though not always for the better.

Everywhere in this meditational landscape – from the great house built from the slavery of human beings, to the church paintings defaced by a scratching finger of Puritan disapproval – there are marks of loss and suffering caused by the escalation of a local observation, right or wrong, into an imposition upon everywhere. Where some local dispute fuelled by a jealousy or the ambitious rolling out of a dubious scientific theory has been transported far beyond its origins to where its 'principles' can be applied, detached from their circumstances, with a flexibility that facilitates self-interest, callousness and bigotry. So, as you take this journey, test any ideal you find along the way against what you feel immediately around you.

Focus on one grain of sand; first acknowledge the beach from which it comes, then pay attention to it as a thing alone. How does it feel against your skin? Which of its surfaces or edges can you feel pressing into you? What tiny textures does

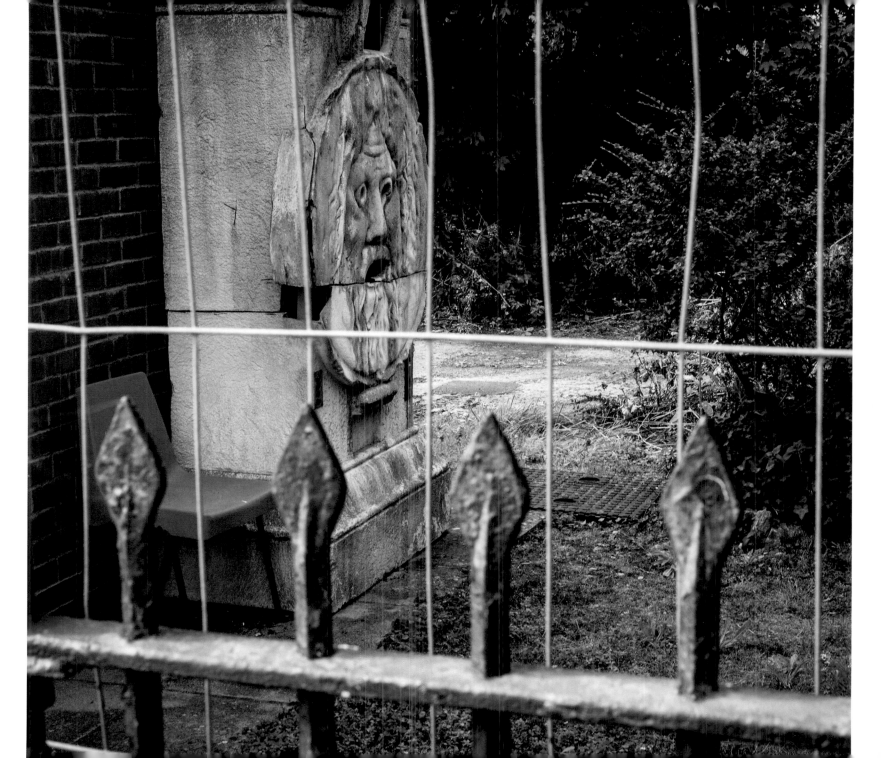

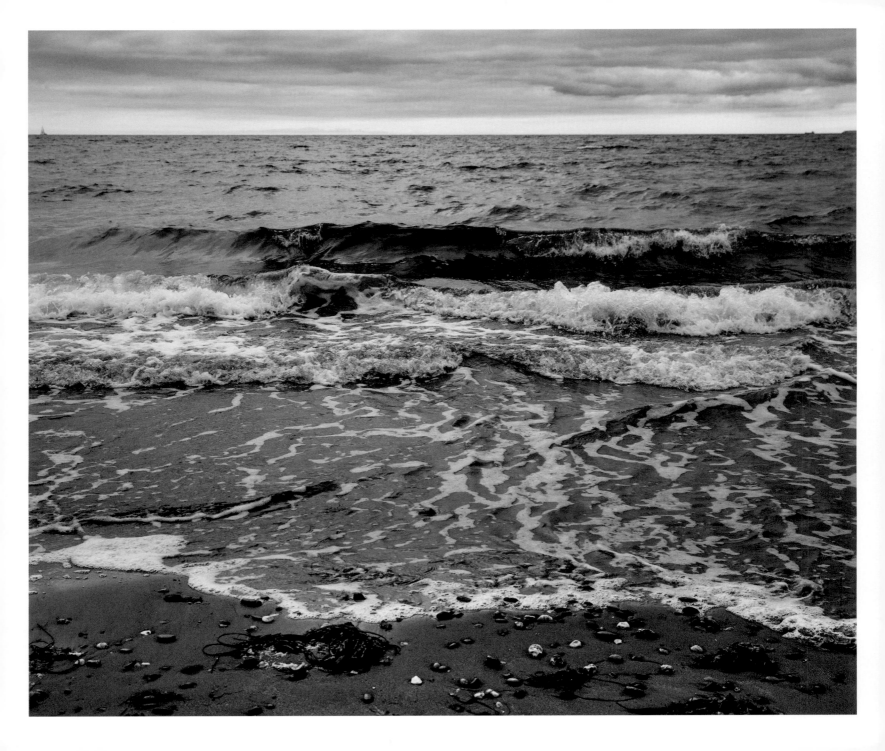

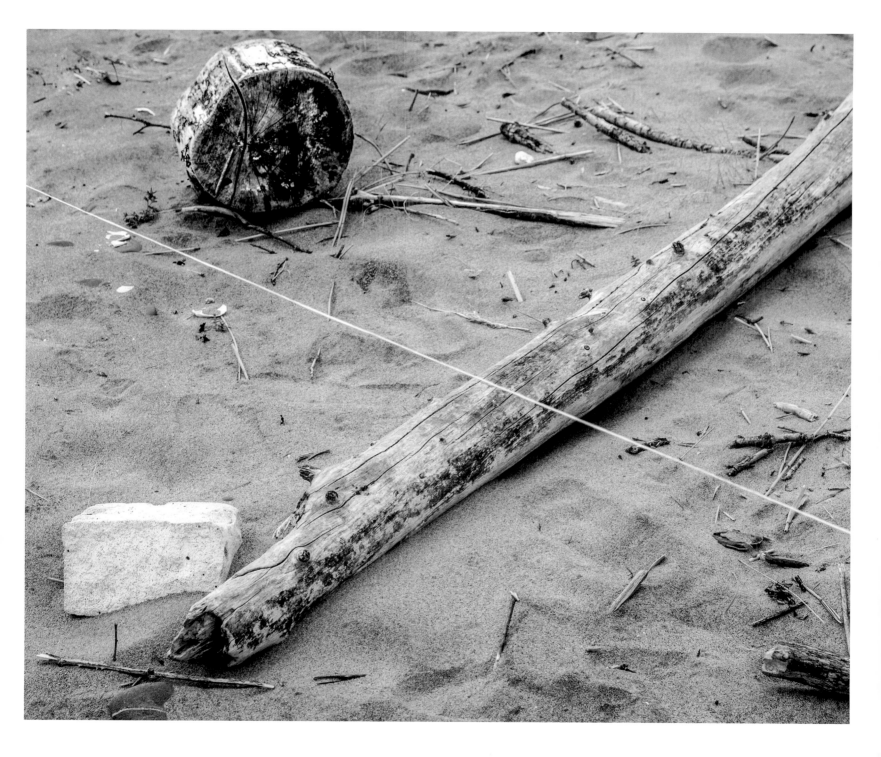

it imprint on your flesh? Even as one of many parts of a beach, it is also 'a thing' in itself. Respect its thingness and discreteness.

Now turn back to the stretch of sea. Let your eye roll out to the horizon.

There is no way back across its smooth plane to a lost security in certainty or sameness. Feeling the dunes shift beneath you, contemplate the unpredictability of the waters before you. Contemplate the varieties: of sea and land, of fish and bird, of you and those you love. Even the spit of sand on which you sit grows and shrinks, spawns lagoons, once supported houses that were blown away by storms, and today is sustained by buried steel gabions that temporarily keep its sands from vanishing into the water. Consider the precariousness of your own situation, of all foundations.

Watch each wave wash up gently on the shore. The weather is calm now.

Contemplate how the same properties – reflection, wavelength, interference – apply across different kinds of waves: waves in water, sound waves, radio waves and microwaves, peristalic waves in your intestine. Yet, despite these translations across different materials, there is still no absolute universality in common forms; we have known for over a hundred years that there is a fundamental unevenness in existence itself; that at a sub-atomic level all things exist only as probabilities. In this unstable cosmos 'here' is always a moveable feast.

Stop for a moment. Close your eyes, and, in your mind's eye, watch white horses on a great expanse of blue. Enjoy their fine tracery while it lasts. A bare breath of wind makes a ripple on the water; follow it, until it flattens.

Then return to the text…

As a thing like a pebble or a seagull has an integrity in its own being, so a place is made up of unique crossings and traversals. Unbounded it may be, but it is not transferable to any other junction or forum. Details are most profound when *in situ*. Whenever things are moved, they are changed but, in part, they are also destroyed.

Stay put for a while, focus on where you are. ❖

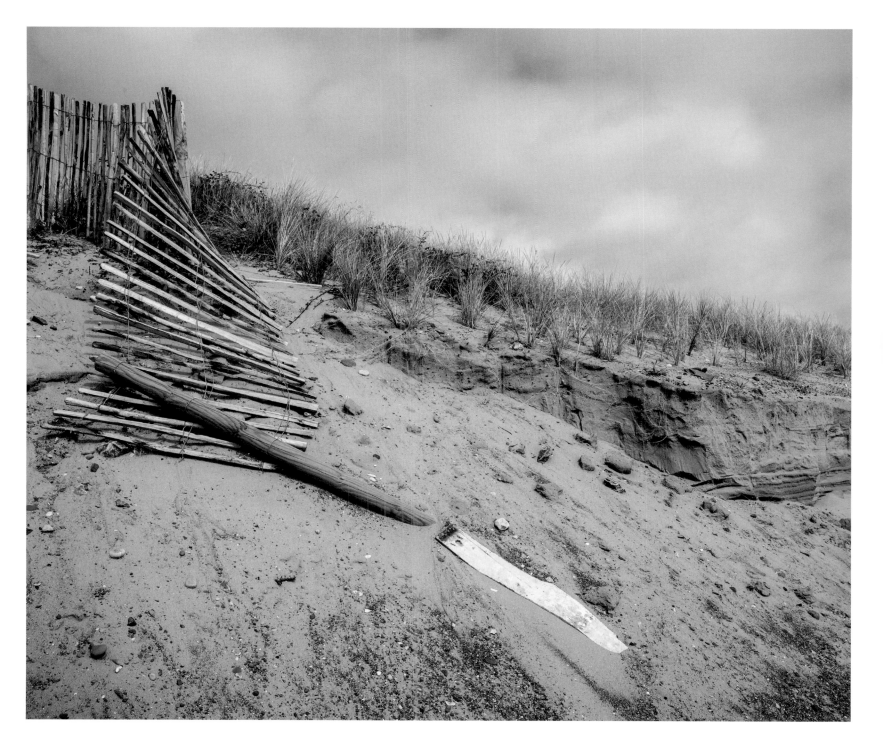

DAY 2

The Deep and Surrendering Ideals

WHEN YOU ARE READY, walk towards the waters. You have moved a little down the coast now, a short way from the dunes. As you walk to the sea, you will notice a high promontory of red rock directly to your left. It towers above you, seems to accompany you; it lies in the sand like the giant body of a resting dragon. Where it meets the sea, the cliff is like the dragon's giant head. Pieces of driftwood on the strandline seem to have eyes and slit mouths; one is like a whale, another like a sea serpent.

Before you step into the sea, consider for a while those accidental appearances of faces in stone, snakes made of silt, birds made in shadows between leaves, and maps of continents shaped in spilled beer on a pavement. What are they? You could not read and make sense of them if their templates did not already exist in your mind; they are an extreme example of how we see what we already know.

Rewind. Unsee the dragon, the whale and the sea serpent.

Re-see the end of the red cliff, the slab of wood, the smoothed and broken bough. See what they are made of. There is as much to be reverenced in sandstone or water-smoothed birchwood as in an angel's face or a monster's tail.

Look back at the dry land you are abandoning for a while; like undressing from a bath robe, strip yourself of your templates and drop them on the strandline. Step into the bluey-green. It feels cold to begin with. Slowly walk forward for a few feet, the sand soft under the soles of your feet, until the water covers your feet and waves lap against your ankles.

Feel how the waters of the deeper sea might support your body. Imagine how your senses might spread out along the ocean floor. Practise for a while feeling out with those senses to navigate giant shoals of tiny fish, sea floors of sharp coral and basalt boulders, steer around a rolling of whale bodies and clock the gazes of the eels within their pits.

Imagine how it would feel to float.

Give up any templates you still have left. Let them dissolve and slip between the currents. Let nothing frame how you see the world. Then follow their example: liquefy your self, deliquesce, decay like an unstable atomic nucleus and radiate your instincts and sentiments through the drags and undertows.

Take a few minutes to dissolve.

You are translucent.

Fishes swim through you, jellyfish propel themselves in you, giant waves reach down to you and bioluminescence shines on you. And yet you are still paddling.

When you are ready, let the currents buoy you, then turn you around. Allow the trailing 'feet' of the white horses on the surface to gently tumble you. And yet you are still paddling.

In affable confusion, consider your relation to giant and tiny things; let your mind float free from abstract polarities. Focus on the scuttling crab on the sea floor and the great dome of blue above your head. Let things soak into each other, until 'creature' and 'sky' are the same. Look back to the shore … the planet is scarcely recognisable.

Now, turn to the sea, allow your eyes to drift to the horizon, feel your toes sink a little into the ocean bed, and relax to the touch of a hermit crab as it hauls its shell-house across the top of your foot.

Do your senses long to run with the currents? If they do, allow yourself to imagine what it might be like to drift from ocean to ocean as sea snakes ride the Gulf Stream or as

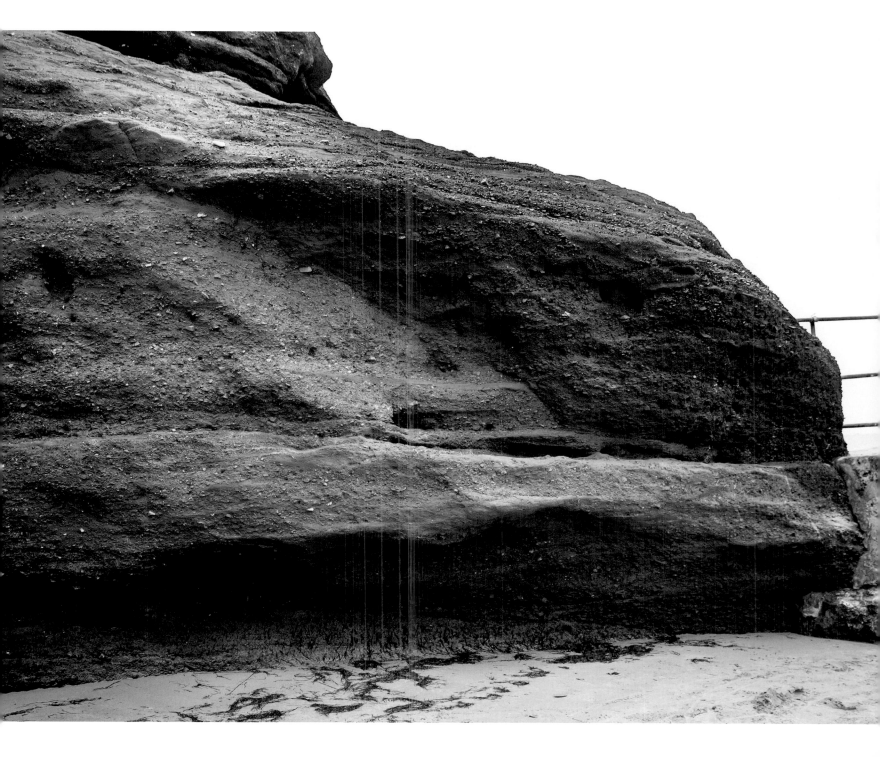

sponges hitch a lift on tsunami debris.

Imagine how the ocean's monsters intuit its caves, chapels and living organisms.

Imagine yourself as sea monster; hear the snort of your breath, smell the saltiness of your tentacular limbs.

And yet you are still paddling. Imagine then, an ancient people, standing like you, ankle deep in the water; what was it that they saw? A giant whale beaching? Something long and gelatinous washed from the depths by a fierce storm? Enough to bring them to worship 'the deep' and name themselves after it?

Consider your own being in that ancient world, long before the Romans came here. See with the eyes of an ancient people, grasp with their hard hands, shed their blood. Give in to the undertow of the past as it tosses you from your own ocean of landmarks into theirs.

Through their eyes see what approaches, feel their rising awe and fear and admiration; something alien is swimming from the far distance towards you and it is getting bigger. Dive in and swim to meet it.

The Coastal Water and Falling Head Over Heels

Vampyroteuthis infernalis, the vampire squid from hell, might not seem the obvious choice for a spiritual guide. But trust her; explore her space, it lies deep down somewhere between human and unhuman. With her propensity to commit suicide by eating her own tentacles if captured, the Vampyroteuthis is more sensitive to how the world is than we might at first think as she swims fast towards us.

Watch her carefully and without fear; though she is terrifying. Give her the benefit of the doubt; take a chance on her.

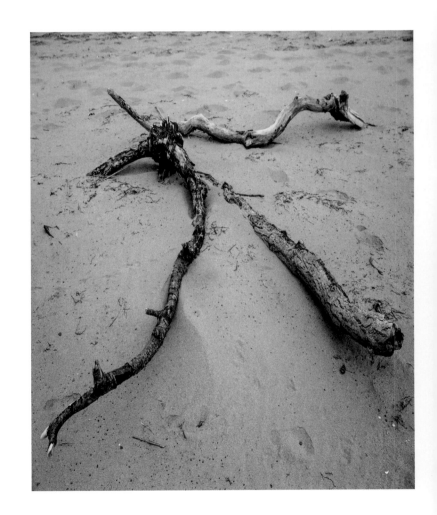

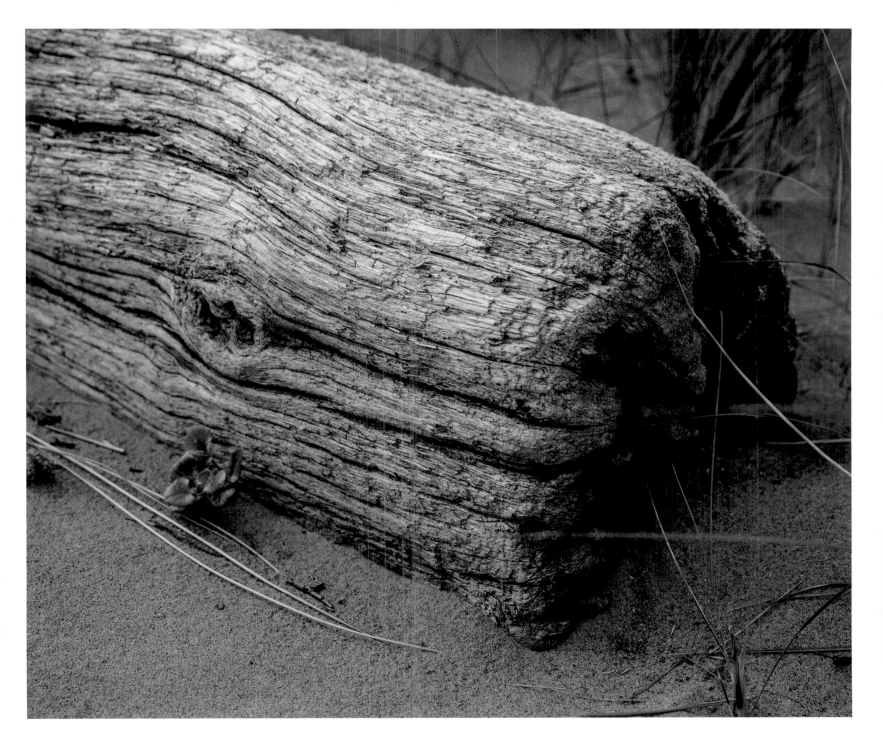

Observe the common physical structures, ancient life path, and faint trace of deeply scored memories that you share with her. She is your guide to re-thinking your presence in the alien depths of a world scarred by a monstrous climate distress.

Enjoy the odd spatial relationship of her brain to her feet; follow this relationship and feel her swing you through a 90-degree shift around your symmetrical axis, so that what was once before you is now below you, what was behind you is now over your head.

Lose yourself for a while, let go of your orientations and landmarks; let her mess with your mind.

Allow her to challenge your sense of rightfulness and transgression, of heaven and hell.

Allow her, and she will show you the unexpected in familiar places and the familiar in alien worlds.

Allow her.

The free-floating *Vampyroteuthis infernalis* abolishes up and down and upsets the longstanding conservatism of so much mysticism with its common dictum of "as above, so below" – of truths passed down from on high to lowly initiates beneath. She swings mysticism from side to side and around and around. Her knowing is shared sideways; handed on and handed around rather than handed down.

Imagine you are a tentacle of your squid guide. Reach out. Hand yourself on. Truth is not an ascension but an expansion; reach out.

Shoals of impressions turn you head over heels. Swerving schools of emotions sweep you first one way and then another.

Let any feelings, senses, impressions or insights you have right now flow in and out of you; imagine their sharing in long tentacular reachings-out to friends, to strangers, to fellow feelers.

Take your place in a wild sharing of feelings, join a chain of impressions, approach a floating community of connected insights. Like a tangle of seaweed, what appears as a stain on the surface is a tumbling platform for a world of beings: tiny crabs, starfish, anemones and jellyfish. What have you become?

Extend yourself, like the sensitive tip of a limb, through the ever so gently churning blue world, and carefully, warily, feel out for the reciprocal search of others – and of any Great Other – gently feel for the feelers feeling for you.

She is a city, a living map. If a patch of seaweed can transform you, what can the squid do for you? What will you become with her?

Now swim to shore. Be attentive to how you swim with a monster that is impossible to change without you becoming at the same time transformed by it. ❖

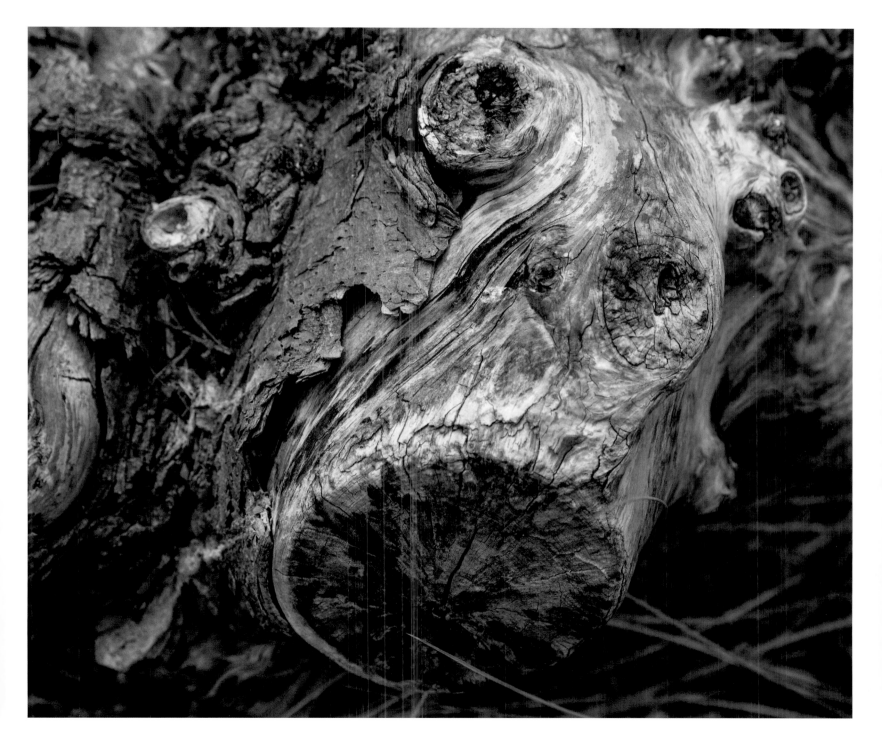

DAY 3

The Vale Without Depths and Emptiness of the Built-Up Areas

TURN YOUR BACK on the waves and Vampyroteuthis, the churning darkness. Like Samael, the archangel, you are now blind, and yet you see. Where once there was something meaningful, now a nothing is revealed to you. Where there were once things, full with memory, powerful imagination, wild fancy, ripe desire, now you see nothingness.

Your meeting with Vampyroteuthis was intense and meaningful, but did you expect to gain something from it?

You walk back across the dunes, but their shifting sands, in myriad wind-borne and sea-given shapes, mean nothing to you. They are stripped of significance. They just are. You walk through the fun-fair, but there is no amusement, only machines. You follow a tree-covered tube-like green lane through the fields, past broken greenhouses and an algae-covered caravan standing empty in a field of brown scrub and low concrete walls.

And on to the town, and the suggestion of pleasure and escape, but each building there is a facade. You feel the cold. You pass the derelict hotel once owned by a malevolent horror writer, a rusty baggage conveyor, rooftops filled with ventilation shafts and other intestinal machines. Above an empty concrete 'canyon', a buddleia bush draped with discarded clothes growing from its cliff, is a lift shaft; one of the control buttons points sideways rather than up or down, but you are not ready to push it. Snow begins to fall heavily, and settles, turning everything the same colour. You slip carefully down concrete steps behind the facades, past the graffiti, a face made of various genitals, captioned 'SEX IS LIFE'. Everything looks ordinary, but when you approach it, it is hollow.

Old stories and memories of TV programmes about ghosts in the machines and ancient rocks with a message may help you appreciate the way these ruined and grubby spaces are trying to speak to you. They are not your enemy.

Take a moment to look at the lifeless pages you are holding, the emptiness of these words you are reading. See in them nothing but ink applied to paper. There is no meaning here. You could be doing something else. Reading a different book, climbing that shining peak, doing the cleaning, making love, running away, dancing in the wind, cleaning your teeth, touching the rain on the pavement, putting out the rubbish. Everything is equivalent. All is open and flat in this Vale Without Depths; it runs from the sea through the town to the edges of this page.

The Portal and the Immensity Beyond

How long must you stay here, wandering alone in the empty alleys behind the busy streets and glowing hotels? Is this a punishment? A purgatory? Would the payment of an indulgence quicken your escape? Or open up a hell? Have you paid, in the past, a priest, a counsellor, a life coach to help you get out of here? Did it work?

Finding yourself lost in abject lobbies and holding bays, even this small town seems the size of an impossible sea monster, has the breadth of an ocean and a separateness like that of distant stars.

When cosmologists first began to grasp the true extent of the universe, individual human lives at first seemed shallow

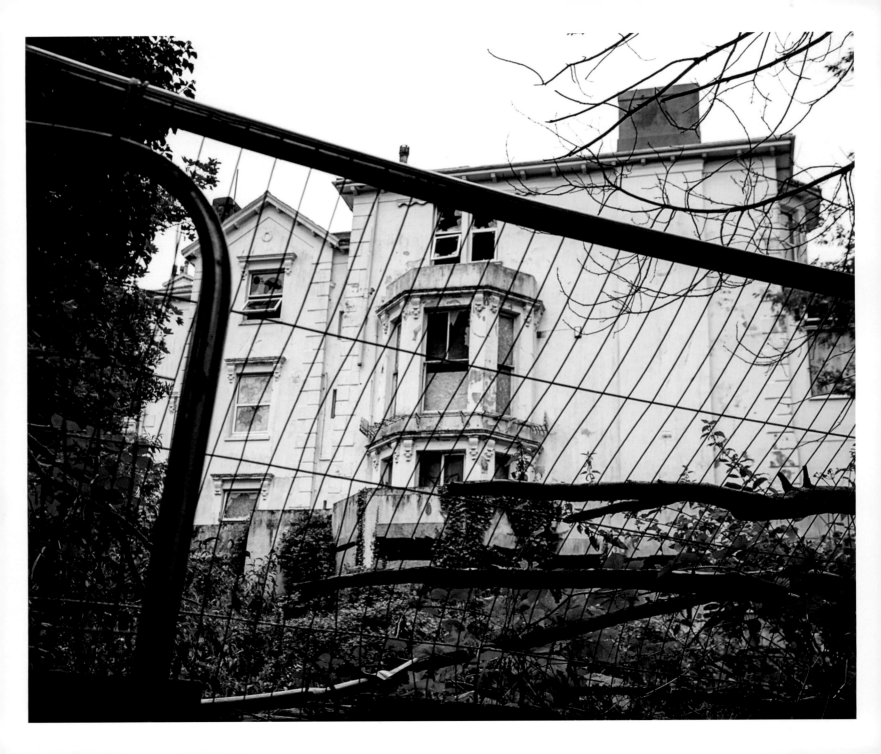

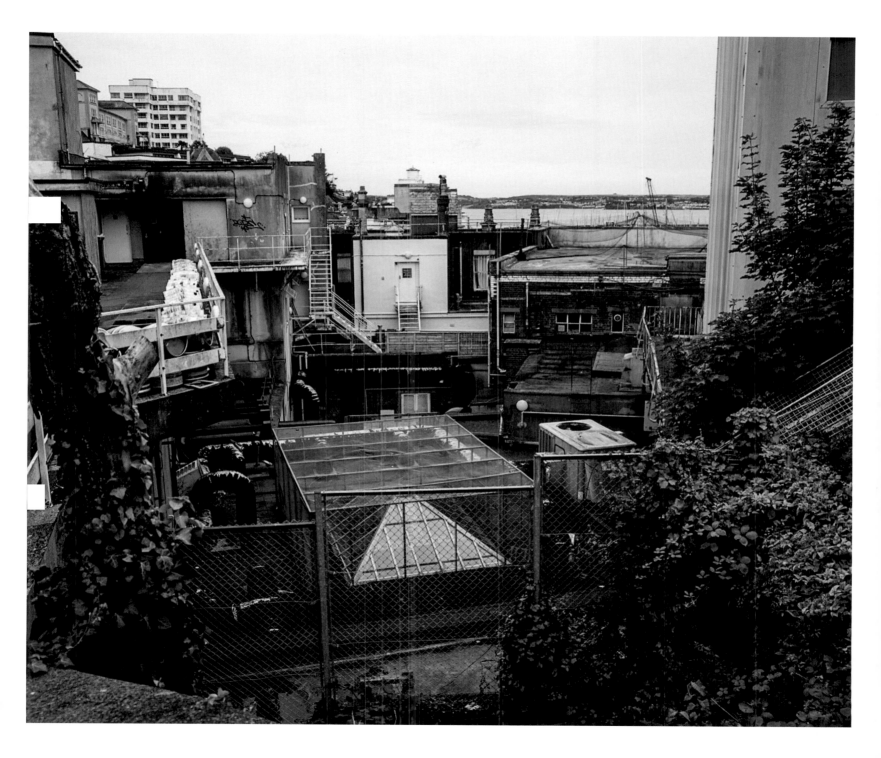

and meaningless measured against the depths of space and time. Now, however, those same scientists, to understand the workings of the vastness, have shone a light on its workings at the tiniest scales, opening up the dispersal, superposition and ambiguity of tiny things across great fields of probability in which we, middling humans, have a new significance. Not as giants striding the stage of a planet, but as connections, tiny webs of coincidence, able by our provisional natures to intuit subtle fields that stretch across the cosmos.

Even from the concrete abyss of the city.

It is time, for a while at least, to stop worshipping or worrying about personality and to feel the dread of the cosmos; that panic in the face of enormousness that can open our senses. Not fear, not even excitement. Not something that you feel at all, but that thing when you are felt by the cosmos; when you feel the feelers feeling for you.

So, save your money. You do not need to be cleansed, only to follow your path, even when it is a dirty back alley in a small and unglamorous town. You lack nothing you need. This Vale Without Depths is not your home; it is your lobby, your waiting room, the tunnel to your field of dreams.

In the distance, you see steps, leading up to heavy double doors. ❖

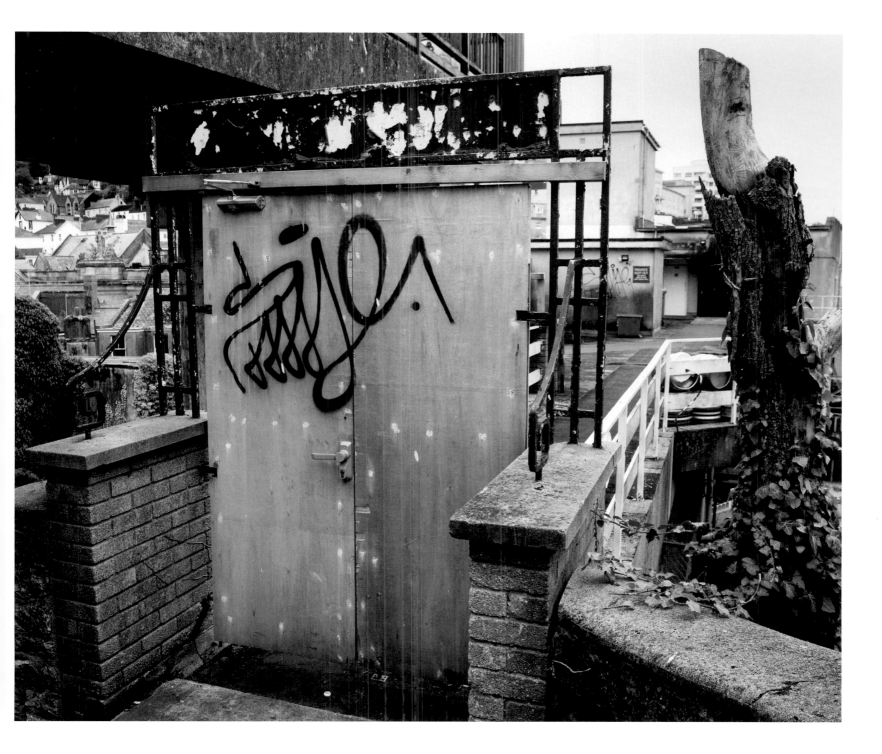

DAY 4

The Museum and the Influencing Machine

THE DOORS SWING OPEN. You are greeted by a kindly old lady. "Do you have everything you need?" she asks.

You are not sure.

The lady hands you a guide. This is a museum. You unfold the guide and look at the map of its layout. It is not a set of plan views from above. Rather, the galleries are shown like layers of rock. Overturning geological time, however, the museum's more contemporary exhibits are on the lower floor, the oldest are on the highest. Via the stairs or a lift, you can move up and down through history. You wonder, why this particular arrangement?

Follow the map.

In the first gallery, everything is familiar. Glass cases full of things, each carefully described. Explained. Objects, previously without depth, start to fill out; memory and desire return to give them meaning. After the eeriness of the Vale Without Depths, you start to feel much more comfortable. More at home. As you walk through the gallery, you begin to puzzle at the arrangement of the objects. Here a sewing machine has been placed next to a stuffed squirrel. Why? And the descriptions on the labels seem irrelevant to the objects. Next to an umbrella is a handwritten journal entry about a local folk tale of hobgoblins. And leant against the sewing machine is a picture of Arthur Balfour, 1st Earl of Balfour, British Prime Minister from 1902 to 1905. Why is that important?

The curators' choices grow increasingly chaotic. What sort of gallery is this next one? What sort of history is being described? The second and then third floors of the museum are full of cabinets that contain objects that are both familiar and strange. Unexpected mutations, uncomfortable combinations of the organic and the mechanical. Here, a vulture with mirrored wings and tendrilled feet. There, a box whose angles are like nothing you've seen before. A severed hand holds a globe, within which clouds move and float around you and within you and beyond you.

On the third floor, beyond the final display cabinet, is a separate room. Inside is a huge machine, its central box surrounded by barrels and pipes, surmounted by the vanes of a wind turbine. You read in the guide that this is an 'influencing machine', driven by the principles of pneumatic chemistry; its purpose is to control and influence the minds of those loyal to one power in favour of another. The machine torments its victims, cracking them like lobsters and working their flesh with a nutmeg grater, until they are ready to commit treason against whatever they hold dear. Crazy, yet it sounds kind of familiar. What might it drive you to?

You look up from the guide, and the machine is gone, the room empty.

The Storeroom, the 'Bonelines' and a Map of Possibility

A spiral staircase takes you to the fourth floor.

Can you still trust the guide?

At the top you squeeze into a small room. There is no attempt at exposition here. Heavy, sliding floor-to-ceiling metal shelves nestle against each other. To access their contents, each section of shelving has its own wheel, a turning of which creates a new corridor along which the visitor can walk and view the exhibits. But the exhibits are not exhibited. They are all packed away in light brown cardboard boxes.

Each box is labelled. Take down one of the boxes. Open it up. Inside is a jumble of bones. Some are teeth, others

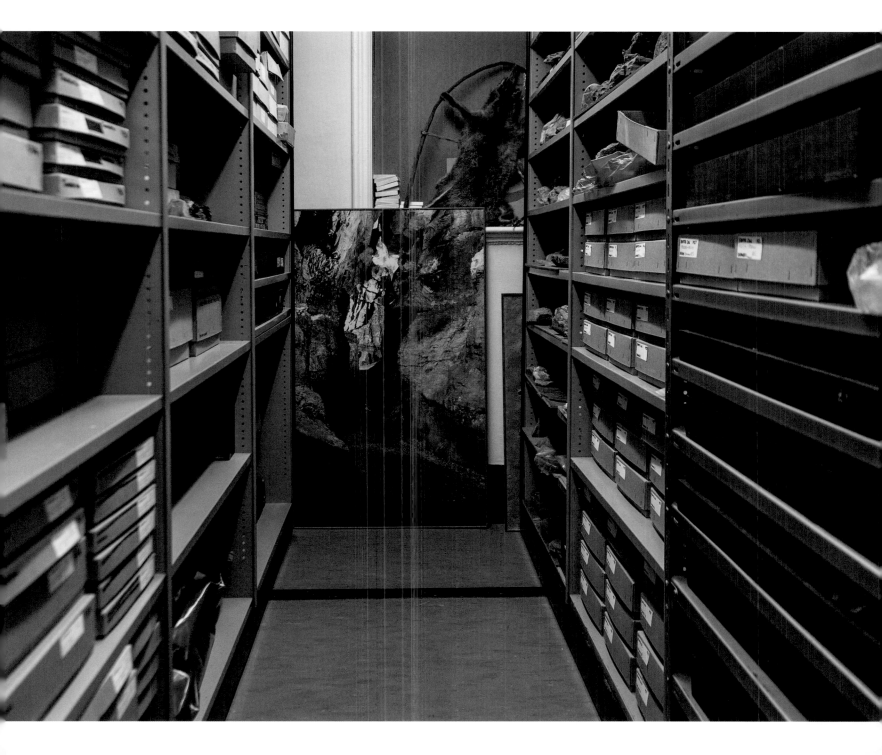

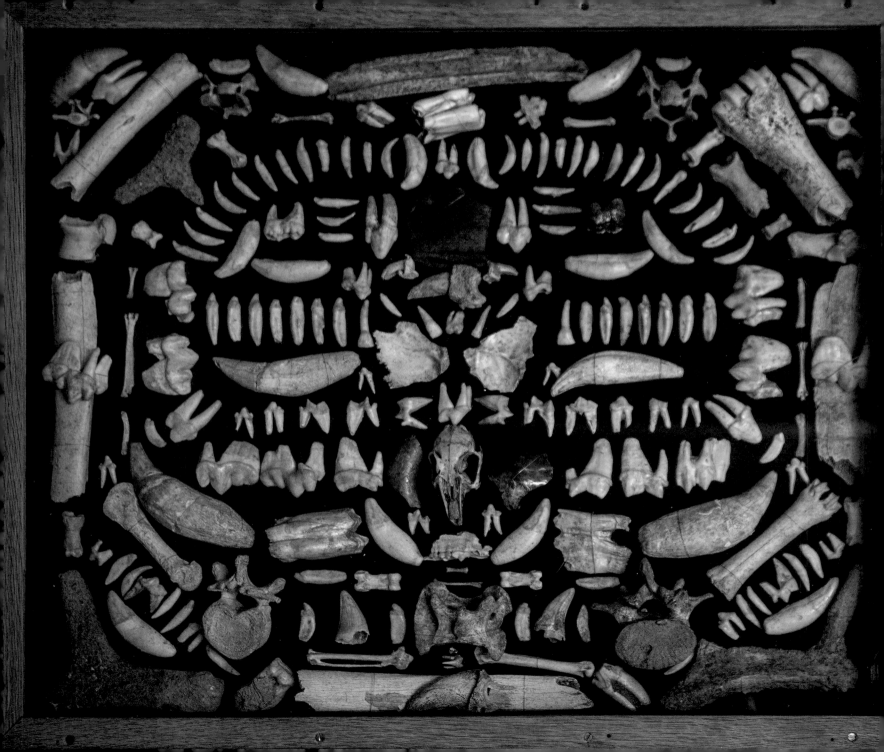

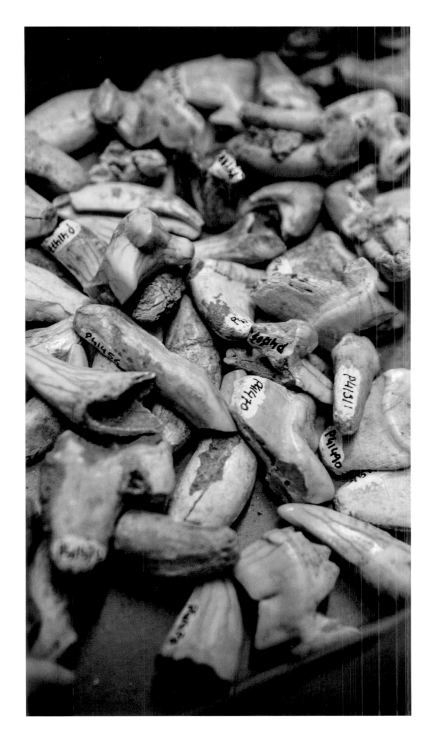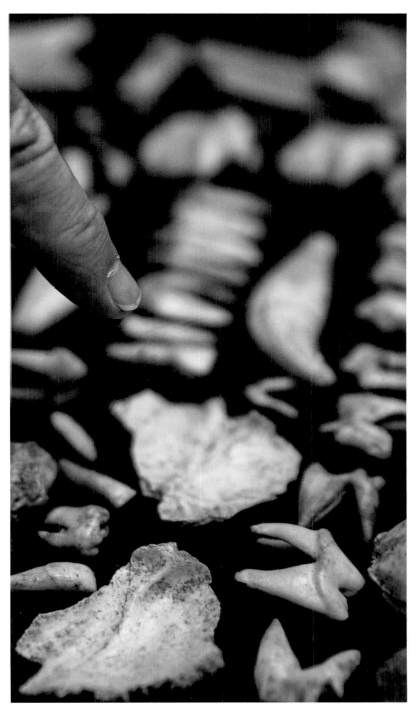

fragments of jaw. Coprolites. Femurs, pelvic girdles, clavicles. Skulls. Each fragment is numbered, but the numbers seem to bear no relation to each other.

Open more boxes. Some larger, some smaller. Each is the same. A jumble of animal remains. You speculate about the species. Perhaps dog? Bear? One label says: 'Hyena'. Was Africa here once? How slippery were things? Is that a human skull piece? But none of the boxes suggests a familiar taxonomy. Here everything is possible. Including the past. Entangled and mixed up. Almost as if these might be the many parts of a single great organism; a giant beast in a single moment in time, a turning point with infinite possibilities and infinite ways forward. Only looking back at evolution's path is it fixed; in the present it can begin to go anywhere.

Open some more boxes. Stand in the cave of the store. Circling hyenas swirl around you. Everything has a future. Every expression of life's exuberance is manifest inside the brown cardboard containers. Each radical new form, each possible and impossible creature, burns for a brief moment in the darkness, then returns to potential. Replace the lids on the boxes, return them to the shelves, turn the wheel, close the sections.

You are in a cave where every mutation is just and right. There is no suggestion of purpose or plan here. Simply the shadow of the Angel of History rummaging through the routes of the past; and the lurking spirits of randomness and mutation ready to throw up a twisted miracle.

On a table, in the far corner of the room, is a single box. It is labelled 'Bonelines'. You lift it up and remove the lid. Inside is an old-fashioned glass-topped case. And within this, a collection of bones arranged in a pattern. At first you wonder if there are old humans in there, but then you are drawn to the arrangement. You feel that it suggests a map. It feels good to look at. No ordinary map, though; one you understand instinctively. Read from the ways the fragments are positioned. You know exactly what to do. You know exactly where to go next. ❖

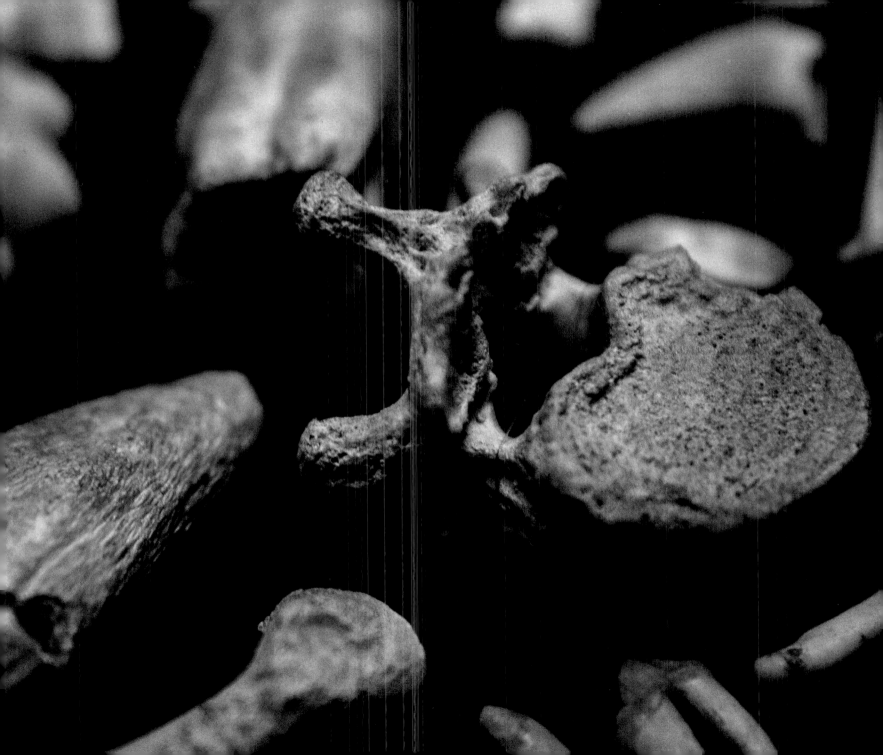

DAY 5

The Manor House and the Remnants of Utopia

YOU HAVE TRAVELLED from the dunes, into the deep, across the Vale Without Depths and up and down the museum, but the map of bones has brought you now through narrow lanes, deep into the countryside, to a long potholed drive that leads to an old manor house.

The exterior of the building suggests Georgian, but to the left stands a more recent Edwardian extension, with an early use of concrete. Two periods struggle for an uneasy truce, building on shared features, yet arguing over materials.

Either side of the door, level with the lintel, are stone faces; eyes wide open, as if surprised by bliss. The door yawns welcomingly and you enter. Inside the lobby, wallpaper fades and peels. The house is empty. You have the run of it, can go where you like. Feel free to explore.

The floor of the first room you enter is dominated by a huge and brightly painted map. An island, with ports, houses, roads and railways. A place to make utopia, the bounds of which are marked by the dimensions of the map. Dismantled furniture and packing cases line the room. You wonder how long this map can survive; whether what was dreamed here will remain, animating the lives and loves of all those who placed their hands and hearts on this map.

From the map room, you climb the stairs to the first floor. The next room you enter contains just two things. On the bare wooden floor, a double mattress. Above this, high on the wall, a round plaster relief. Three nude male figures in brilliant—almost blinding—white; two embrace, the third looks away. One holds a scythe. The suggestion is of something classical: Greek or Roman. Who are these three? Philosophers perhaps? Youthful tillers of the Mediterranean earth? Are they brothers? The bare mattress suggests that relationships here were more than filial … though the building does not suggest eros, there was love here.

Along the corridor, a second room. A huge desk and office chair. Bookshelves, roomy and empty; something oddly modern, the ghost of which now gently fades.

A Vista and Vision of What May Be Coming for You

From the empty office, you descend a narrow spiral staircase down into the cellar. This staircase, at the heart of the house, curled and confined between later rooms, is Tudor. The cellar, with its rough pillars, appears medieval.

Time in this house runs at different speeds. Many periods are nested within one another. Like a model of the world, this house has layers: Georgian, Edwardian, Tudor, possibly medieval, maybe ancient. You are finding it difficult to be 'here', to be present, to be in the now, because 'here' and 'now' are so jumbled in this house. Each of its moments is many moments. Nothing is 'at rest', but events run on simultaneously, like different tracks on a piece of recorded music. Their contrasting speeds cause friction as they rub against each other.

The cellar does not help your growing sense of unease. Its arches house the discarded belongings of previous residents. As with the museum, there is a random selection of items here. Time is no curator. In one chamber within the cellar, directly beneath the utopian map room, sprawls an abandoned collection of toy figures, tiny soldiers and small monsters; a suggestion of dystopian foundations for the utopian island above. On the wall, there is a poster illustrating

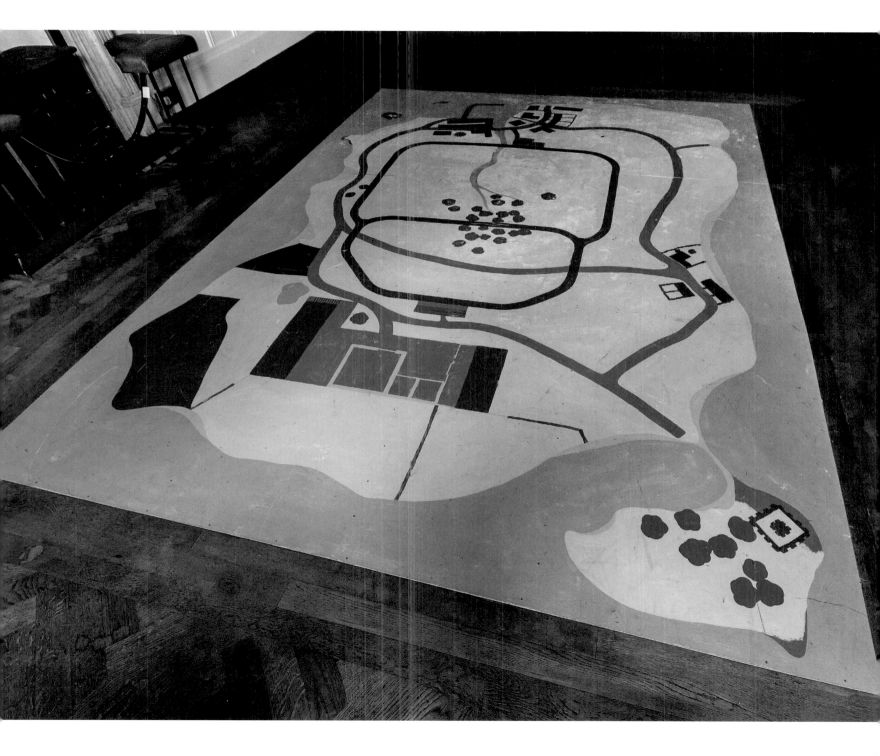

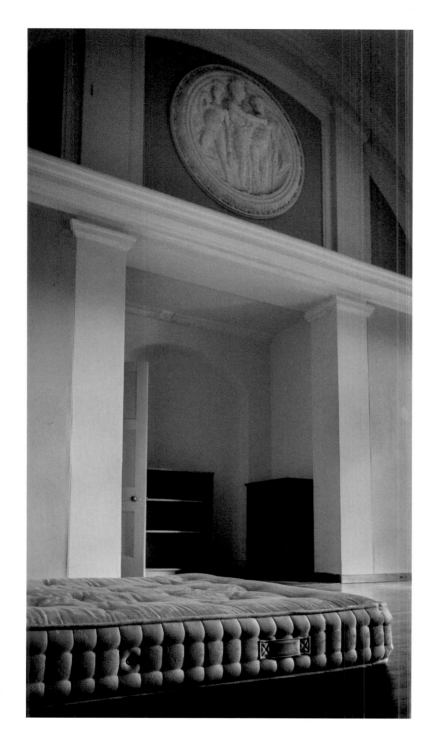

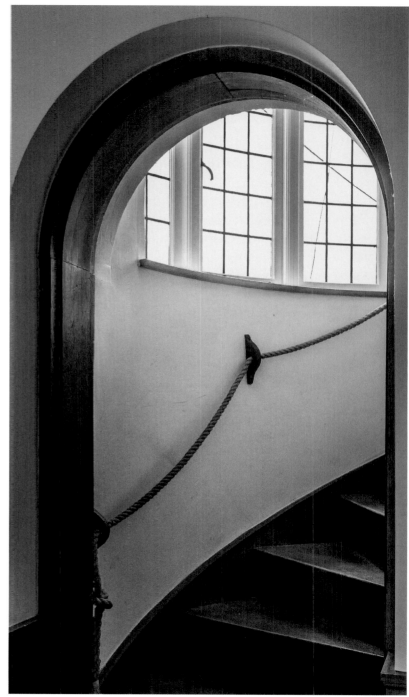

various kinds of shark. It is damp down here. A single bat hangs asleep from the ceiling. Everything dreams down here.

Uneasily. The pillars are genuine medieval, taken from the ruins of the neighbouring priory, hauled down by Puritans, and misassembled in the eighteenth century; simultaneously authentic and fake. The cellar is both one thing and another at the same time; this place and others. The arches that support the whole house are true and false: utopia and dystopia. The rules of life are ambiguous.

But you want plain rules. You want the map to be clear. You desire a route to take you from this location to your next destination. A purpose. Above all, a purpose. Your head is spinning; try to colonise this laissez-faire, patchwork aristo-cratic wildness, attempt to tame it, bring it under control. Wayward passions, surely, will not win the day?

You leave the cellar and sit on a bench by a window. In the distance, you see a hill, framed elegantly in the window pane. Not by chance; this vista was planned. Momentarily and urgently, the hill seizes your attention, and your unease subsides. What is that cryptic rise, so thickly wooded on its crown? ❖

DAY 6

The Hidden Garden and a Kind of Heaven

WALK OUT OF THE FRONT DOOR and beside the house follow a track up to a tall wooden gate supported by two large stone pillars. Beyond the gate, you can enter an overgrown garden. It is made in an Italian style, laid out in the early days of the twentieth century; a Mediterranean Arcadia. Its paths are clear, but the follies beneath its luxurious pines and tall oaks are cloaked with rich ivy and tumbling creeper. There is a hint of Atlantis here. Of a fallen civilisation.

You warm to the orderly nature of the paths. This is more certain, more pleasant. A clear guide; good manners and certain progress. Everything here, despite the overgrowth, decay and fallenness, is given, transparent and precisely signalled. There is a clear aesthetic, as if it were the work of a divine genius.

You find a semi-circular courtyard in front of a low brick building with octagonal portholes. In the middle of the courtyard is an altar-like stone table. You feel the sun, smell rich perfumes, imagine fauns and nymphs dancing by day to Pan's tune. At night, fires and Bacchus. All is in its place; as above so below.

You walk to the empty pool. It rings with the faint conversation of philosophers; listen to the echoes of descriptions of perfect form, of the finer points of beauty. Of how each garden structure here is modelled on an idea. The universal is all-conquering here! And we – trespassers and mortals – are merely crude shadows of higher things. This is a solar palace, where the light is welcomed in from above, revealing everything. All things here will have their explanation; all will be true to its form. There is no place here for inconsistency or doubt.

You revel in this certainty. This, surely, is a kind of heaven?

The Beauty of the Garden and the Intrusion of the Outside World

As you walk along the colonnaded paths you feel the presence of others. You do not walk alone. You are always with another here. An arm around your waist; another across your shoulders. You remember the three figures on the plaster frieze in the house. Here philia – sisterly and brotherly love – walks and talks and acts. Ideas are sweet kisses, theories are written with a light touch of a hand on the nape. Thoughts take fleshy form, conversation is the greatest intimacy. Words flow freely between friends, racing between entwined fingers, touching hearts and binding each closely to the other.

You are never 'here' in this place. Never alone. You are always 'with'. You walk with your confidantes, who are as much you as you are they. Boundaries blur in this 'being with'. All tends from eros and philia towards transcendent agape. Love of the Divine; merging with It! Unshackled and uninhibited, you turn from your shadow towards the sun. Here is a purpose. The highest purpose. To lose oneself in the flame. This, surely, is why you were created, to love freely this creation. To bask together eternally in the warmth of the sun.

A raven calls above you, a deep throaty 'cronk' drops into your reverie. You stumble, trip on the thorny tentacle of a bramble, fall heavily onto the rocky path. You feel the stone bruise your flesh and bone. Winded, you raise yourself up on your hands, each of which is pitted with white flecks of stone.

Back on your feet, you follow the path, more cautiously now, towards the edge of the garden, marked to the north by a tall, dull, concrete wall. You wonder why it is so tall. Was it always hiding something? Are you being sheltered from the crude gaze of those less able to appreciate the subtleties of love and beauty? From the prejudices of those to the north whose lives are slave to chance and crude mutation? You notice a small cut on your leg, no doubt from the brambles where you fell. You feel it sting, watch it bleed.

Turning south, you see that there the wall finishes abruptly. Beyond is the open countryside. Another Arcadia perhaps? But one that is not devoted to a singular idea of beauty. There are layers of history there. Hedges confine what once was common land; theft and divine right scar the landscape. The agricultural is less polite than the horticultural. Many of the fields are bright green – nitrogen fertilizer working its bad alchemy deep in the soil. Just beyond the sweet garden is a rural modernism as harsh and inorganic as the brutalist architecture of any city.

As you turn back to the garden, try to hold on to your thoughts of natural love. But you are troubled by the intrusion of the fields beyond, the inequities written into every boundary. Surely this land is your land, a right of way, a way of life, a common heritage? Can it only be walked freely in your dreams? In romantic visions of Arcadia?

In the distance, your eye is drawn to the hill that caught your attention in the house earlier. The massing clouds frame it now. A stone bench facing the hill has been provided against the exterior of the garden's wall; placed exactly so you can contemplate the hill. Like the window. You slump into its seat. You feel yourself giving up. There is nothing to be gained here. No purpose. You had found certainty in the garden only for the land itself to deny you heaven.

Perhaps the hill can help? Far off, it is gloomy and cloaked in trees; it seems to rise above the troubled countryside. Get up from your seat, retrace your steps, then turn in hope along the lanes towards the Great Hill. Darkness is slipping from the east. You have learned so much already; you worry that it will all slip away. ❖

DAY 7

The Dancers and the Things Their Dances Bring

YOU FEEL THE DRUM BEAT. Below the Great Hill, night falls hard and fast. How many pints of the Dreamer brew will set you free? Baron Samedi, voodoo boss, smiles your way, his face cracked, skin drawn brilliant white over a death's skull. The beat quickens, rag figures appear, grease-black faces and blacker lips, white eyes startling in the gloom.

Excited by the wildness of this apparently ancient dance, its shared history with the draw of the old hill, and the conviviality of the dancers, holding their glasses so the beer and cider swills to the step of the jig, you are pilgrim here. Buoyed up on the excitement outside the pub, beside the village green. You feel as though you might effortlessly float up to the top of the hill on the crow's wings of the black-costumed dancers.

Watch them through the distorting lens of your smeared glass, almost empty now, the Dreamer at work collapsing past and future; dismantling the firmness of boundaries that might shore your stumbling ego against the beat. Sit outside the country alehouse, the sky darkening above the looming Great Hill; what is undoing you?

Put down this book for a moment; what does undo you? Whether for good or bad, what is it that loosens you?

The wild and honest cavort of the black-faced Morris dancers, trespassers and poachers, is still roiling like dark and oily waves. Is that why you feel so strange? Or was it the sensual sophistication of the Garden; did its liaison of subtle forms and a fine taste for desire unsettle you?

Which is easiest to admit to yourself?

The fiddle player grinds his strings, the shining crow-women

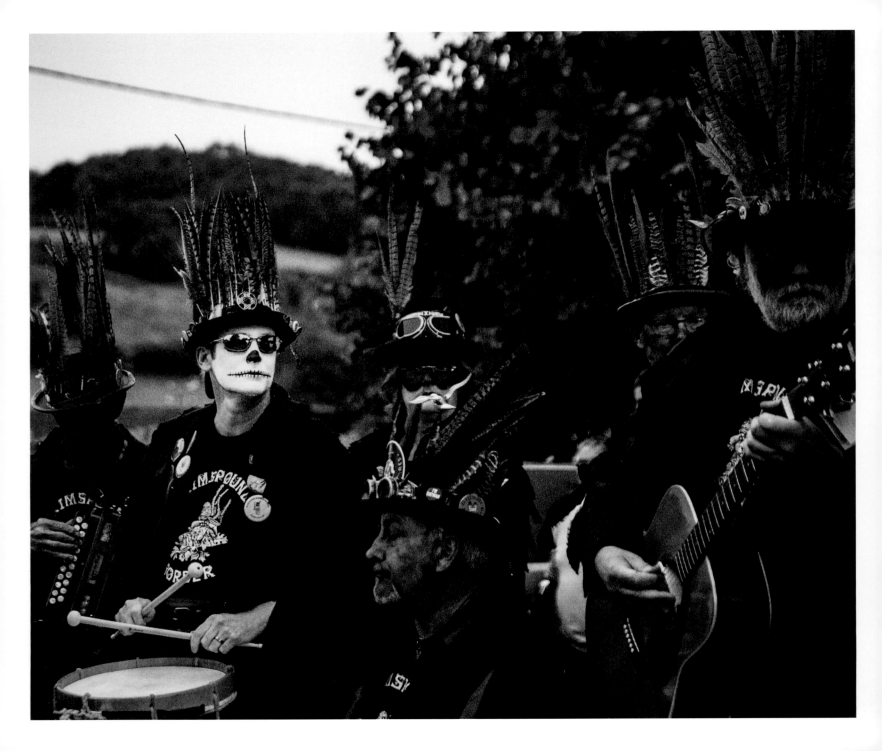

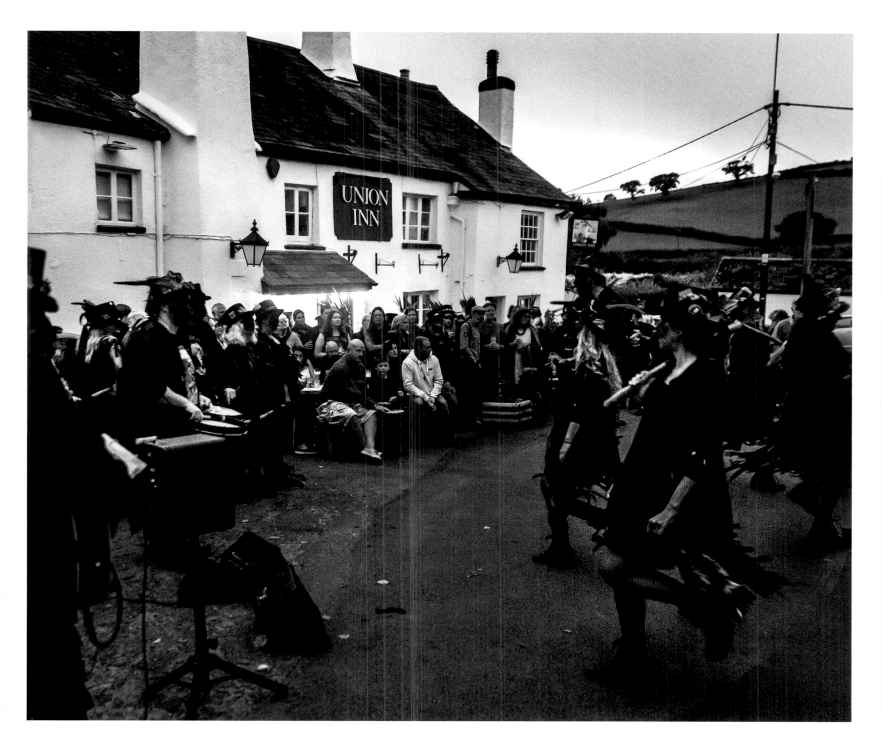

begin a new dance, rags fly outwards, feet leave the ground, feathers trail from black top hats, a single quill flutters through the cold night air and settles in the gutter. Sticks crash together and coarse yells echo up into the darkening sky and tremble among the boughs of the distant hilltop copse, waking sprites and elementals who now pour down the hill to join in with the human throng. More Dreamer, more Dreamer … What's that on the edge of the circle? What's real here?

Beneath the Green, Through Dance to the Darkness

You are on your feet. How did that happen? Beside you, avian-clad dancers swirl and twist. Baron Samedi laughs in your face, blood flowing from his red lips, spilled drops are greedily soaked up by the thirsty village green. Perspective is failing, you feel everything collapsing towards you, there will soon be just this place. This village and no other. For a moment, you think you may be dancing with a dragon. It is sight you lose first, leaving only the scent of sex and burning torches to guide your feet through the preparatory hop, skip and sidestep. You move in a miasma. Even the taste of liquid bitterness on your tongue fades to a neutral blandness. You no longer feel the grass beneath your feet, nor any breath of wind or singing in your hair. There are hands upon you

but you have no idea of who or what they belong to. You have neither a sensation of flight nor of the firmness of the ground. You are in a nothing place. All that remains is the beat, the insistent rhythmic heart of the drum. It vibrates and vibrates, until all is vibration. Nothing other than sound prevails. Then it too begins to fade, as if silence were hunting the fiddler and drummer and running them to earth.

From the far distance, from the edges of what is holy, darkening silence approaches. Absolute silence in a shuffling pack, its surging awkwardness and toothsome snarls muffled by the falling cloak of night. This is the great unsounding that marks the end of things: beer, village greens, memory, love, communion and life. The nothing that neither affirms nor denies; the great dark light that just is. And is not, allowing no opposite. Here it is! In the swirl of the coal black dance, you meet the darkness. And now you are dancing blindly and burning darkly! At each turn feel how another citadel of your certainty collapses in a rain of ash. Sense how you are crumbling now; the whole city and multitude of you! Dropping through the green into the black. Into the timeless dance of the glassy … something … smear on the … cracks appear and then disappear with whatever they were cracks in … time melts … a fierce white flame … ❖

DAY 8

Deeper Beneath the Green Where Darkness Loses Its Way

"You are lost..."

Guidebook for an Armchair Pilgrimage

DAY 9

Surfacing…

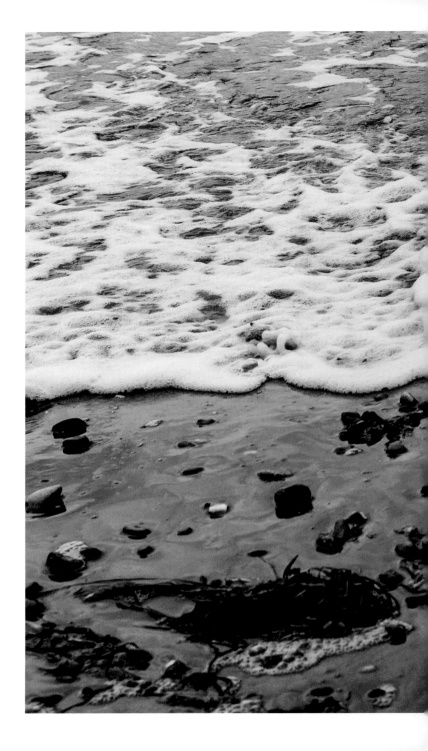

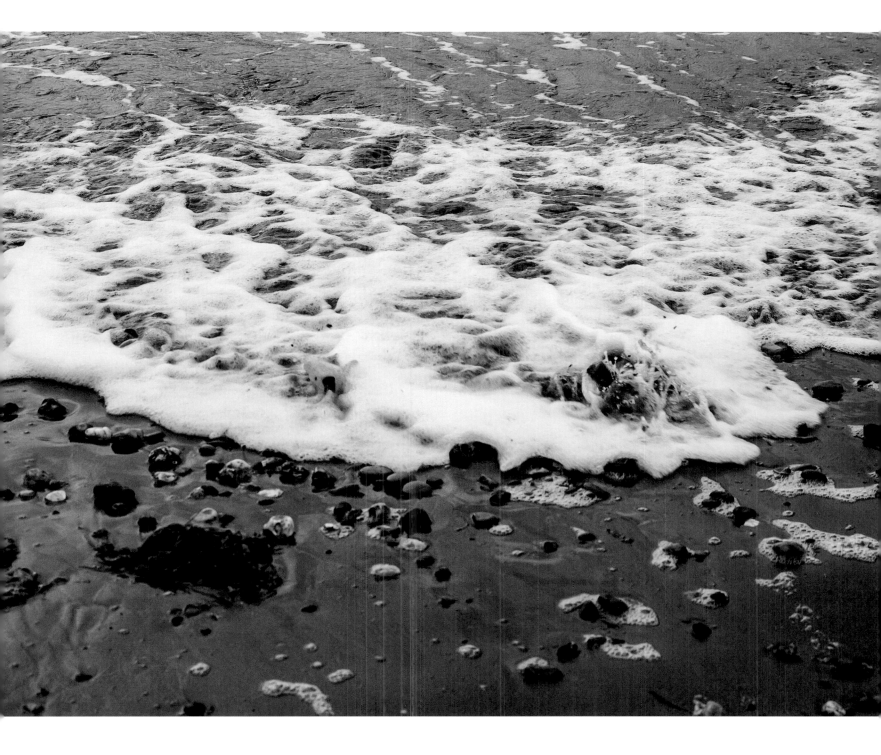

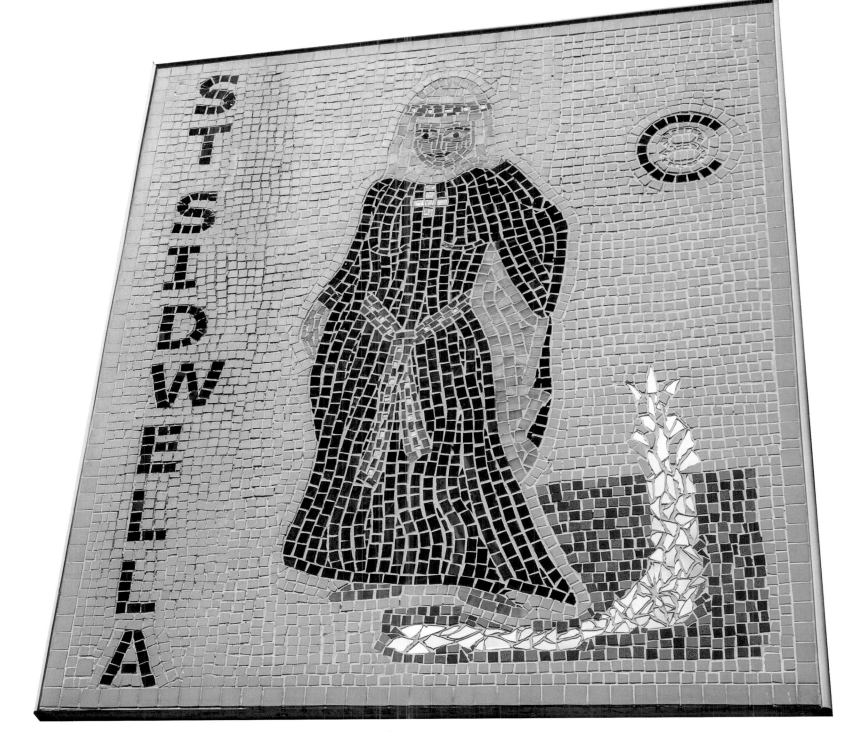

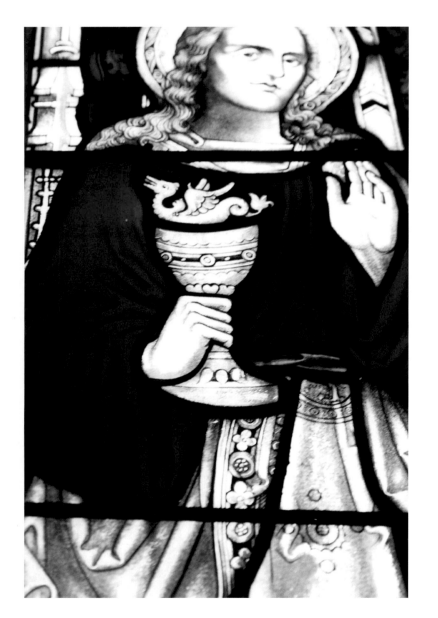

DAY 10

A New Beginning in a Graveyard and a Monument with Clues

IT SEEMS A DIM MEMORY NOW, but not so many days back, you were very close to the centre of your pilgrimage, resting at a pub before approaching a Great Hill for a redeeming climb to its summit. It may have felt then as though you were near to completing the journey. Now you are beginning again from an edge, from a margin. As if all along you have been in a labyrinth rather than on a pilgrimage.

You are in the churchyard of St John, on the edge of a town, some way from the coast where you began, and from the villages you had begun to explore. This is very far from the Great Hill.

Thrown back by sudden bursts of light and darkness, by the swirl of waters, even as they have restored you to a path, you have been driven a long way from an ending. This is not the usual modern-day pilgrimage with roadside signs every few metres and rooms booked at hostels along the way. It seems that there are detours and setbacks on this one, as in Bunyan's tale.

Begin again. You are not the same as when you first began. It is a new beginning.

Look carefully at the detail on the white stone monument. A carved ripple of water rises around the stone sole and toes of a young woman's bare foot.

Can you see how all the twists and turns of your delirium are fixed here? Pause a while and adjust yourself to the firmness of the ground. You may still feel some giddiness, as when a passenger steps on dry land after a long ocean voyage. The land sways, the turf rises and falls like a rough sea.

Look up and take in the whole monument.

The three angels memorialise three sisters. Before you concern yourself with the particular stories of these women (and you will), consider their monument – these angelic stone versions of who they were.

Consider the significance of the stars on their foreheads.

What is the meaning of a forehead?

And what when it wears a star?

Imagine wearing the sun over your eyes; both a badge and a fierce torch to the universe before you.

Observe the wings of the three angels and how, standing back to back, their feathers interweave.

How have you been interweaving? With what?

The angels' haloes are shell-like, their long hair is lifted up as if by wind or buoyed in water. They could be standing on the land gazing up to the sky, or in the shadows of a watery deep looking up to a light on the surface.

Remember how you looked up at the crown of the Great Hill?

Could you have ascended it with wings of stone? Could symbols have got you there?

Near the foot of the monument is an arch made of two stone bulrushes while a third seems to be approaching or supporting the portal. Bulrushes grow in clusters around water. These are used in monumental art to symbolise faithfulness, connection and escape. Above the bulrushes a text describes the monument as being TO THREE SISTERS WHO WENT HOME THROUGH THE WATERS OF THE NILE.

'THROUGH THE WATERS...'

Does this remind you of something? Put it aside for later.

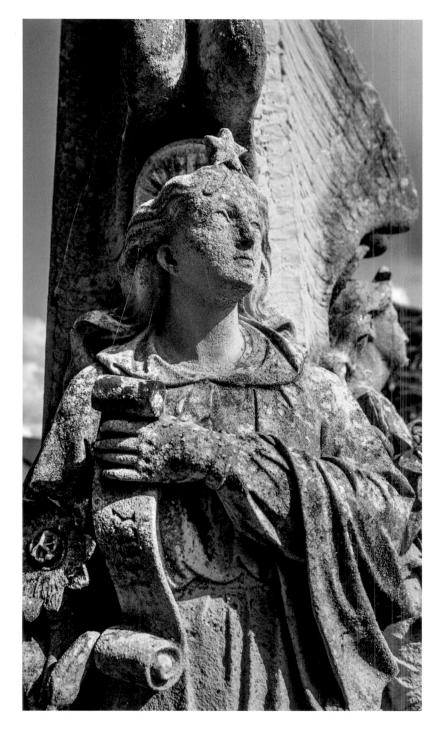

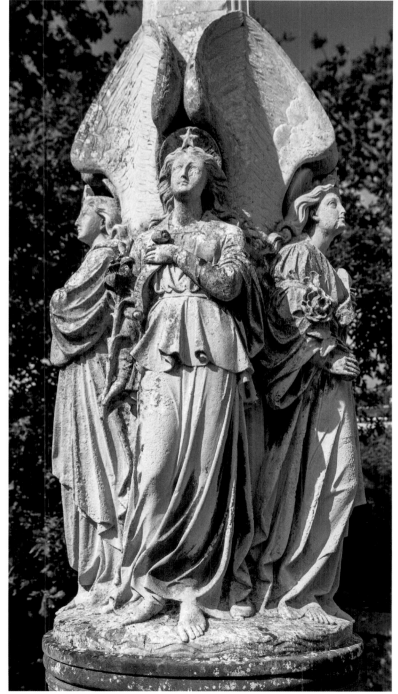

Follow the sisters for the time being. Emily, Rosamund and Mary drowned in the Nile one night, when the boat they were travelling in was upended by a sudden gust of wind as it turned a bend in the river, trapping them in their cabins. The three stone angels are an idealisation of the spiritual escape from the deep that others imagined on behalf of the sisters; but they are also records of the sisters' unfinished business. Because when one makes a beginning to a pilgrimage, there is no guarantee that one gets to make its ending.

Imagine making a monument to your own unfinished business; can you stand before it now?

The Chancel and Unreliable Representations

Inside the church of St John, the statue of Mary is oddly ambiguous. Elsewhere in the churches and chapels of the area, the mother of God steps upon a serpent or a rose stem and sometimes a spring rises beside her naked feet. But here the image is of Mary stepping on what could be either a serpent or a stream, or both: a spring that is snake, a snake that is spring.

In a stained glass window, from a cup held by St John, a snake rears up; poison leaving a spiked drink.

Take a seat in one of the pews and consider where you are, before you set out once more across the terrain. There are so many images of women – martyrs, miracle workers, saints, ancient regional princesses, queens of heaven and mothers – in the chapels and churches (even on the pub signs) along your route. The name Dumnonia ("of the deep") given to this whole terrain by the Romans purportedly comes from the local people's reverence for a goddess of the depths.

You are walking on a terrain where interpretation is never

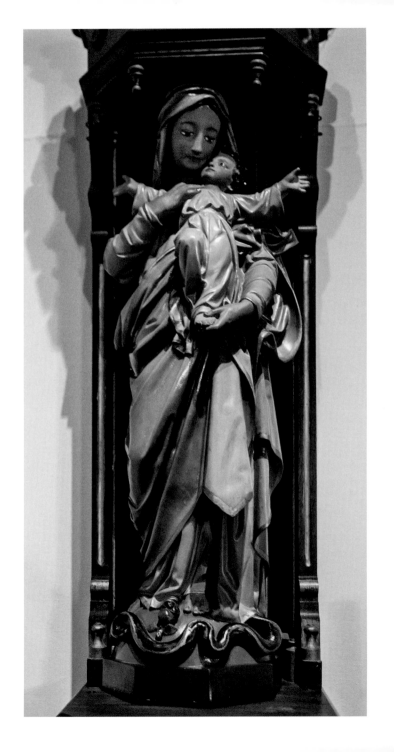

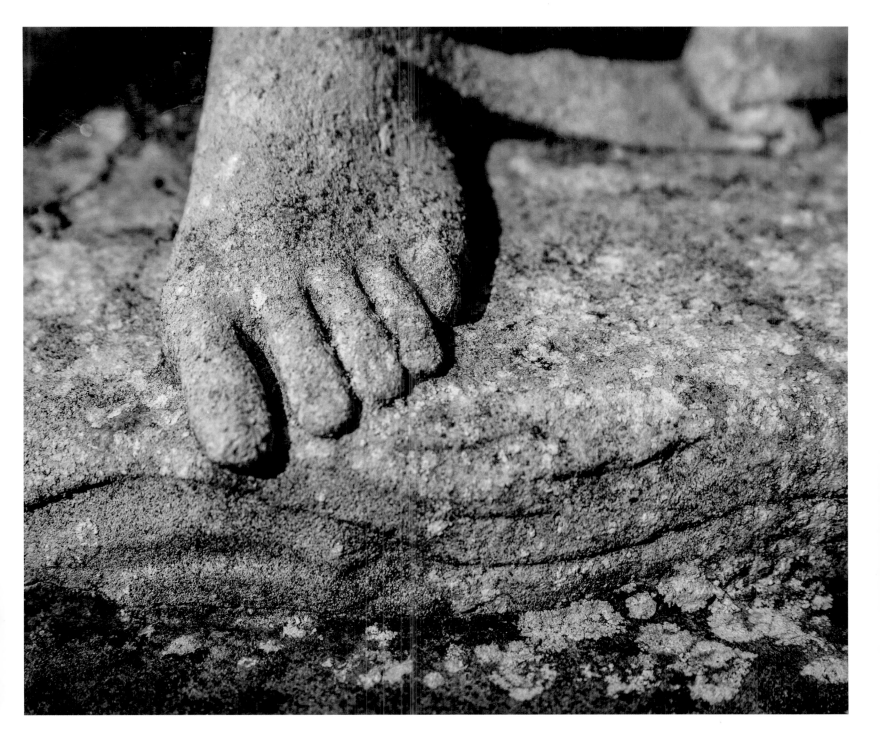

simple, where history is always contested, where accounts have survived only as fragments. Contemplate the gaps between the parts.

Then, consider the story of the three sisters' memory after their death and commemoration in the churchyard here. On board their sinking boat was their brother Edmund. He survived. Traumatised by loss, he dedicated his life to keeping his sisters alive by pouring time, energy and money into 'scientific' experiments in search of firm evidence for the persistence of human consciousness after death, life beyond the grave. After his own death, Edmund 'returned' as a voice at séances held by the mediums in his circle. 'He' communicated a plan: he would salvage a planet drowning in its own cultural decline. He would 'spiritually' father a child with a medium and make a messiah to redeem the world. The brother of former Prime Minister Arthur Balfour was recruited to do the physical part and a son was born. However, by the time the messiah was informed of his mission, he was already a serving officer in MI6 and was disinclined to lead another kind of crusade.

As you sit in the pew here, contemplate how intricate plans go astray, how images and representations float free of their original models. How appearances shift about independently and make new meanings on their own as they move in relation to other appearances. Sometimes hybrids are formed, sometimes new stories.

What representations of yourself might float free of you? Facebook profile? Secret diary? How could your deepest self be pictured? How imagined? How and where might such a representation travel; what and who might it meet and how and into what might it transform?

When you are ready, consider what images will walk alongside you for the continuation of your journey. What representations will be your companions?

Which do you look forward to walking with?

Which do you fear?

How will these semblances engage with a terrain that has, so far, been so uncertain?

When it is time for you to begin your journey again, walk to the church door and prepare yourself to set out into the holy and consecrated world. ❖

DAY 11

The First Ruin and a Lost Entrance

THE PATH IS LONG AND BEWILDERING. It will not get easier. If there was a hope that getting lost and then caught up by swirling lights and tides might resolve things, then that will have to be put aside. Rather than any clear succession of places, there is a cracked and busted route both behind you and ahead of you, a damaged corridor of half-ruined things that stretches far into the distance in both directions. You will find comfort only in fragments.

Take your time on the lanes and along the footpaths that follow. Enjoy any brief calm afforded to you; a respite, poised, able to appreciate the consistency of the parts of surfaces where the ground of green lanes has been hardened and smoothed by a thousand years of hoof and foot falls. Enjoy the vistas across a dispersed countryside of few villages and occasional hamlet-gatherings of homesteads. Shepherds on their quad bikes marshalling flocks, skeletons of greenhouses, the occasional punctuation of a field of solar panels.

But all that is an illusion.

Look carefully in the long grass at the side of the road. There is an old stone there; carved with the broad arrow, the logo of government, and "WD" for War Department. Here on a leafy lane, the last remnant of a military airfield. Turn the corner and there are puzzling buildings behind a high wall and razor wire. A prison; built on the site of the old airfield. Even out here, in the dispersed landscape, there is enclosure and restraint.

Escape! Choose a footpath turning up to the heights, ahead you can see the moor-like expanse. Turn away from

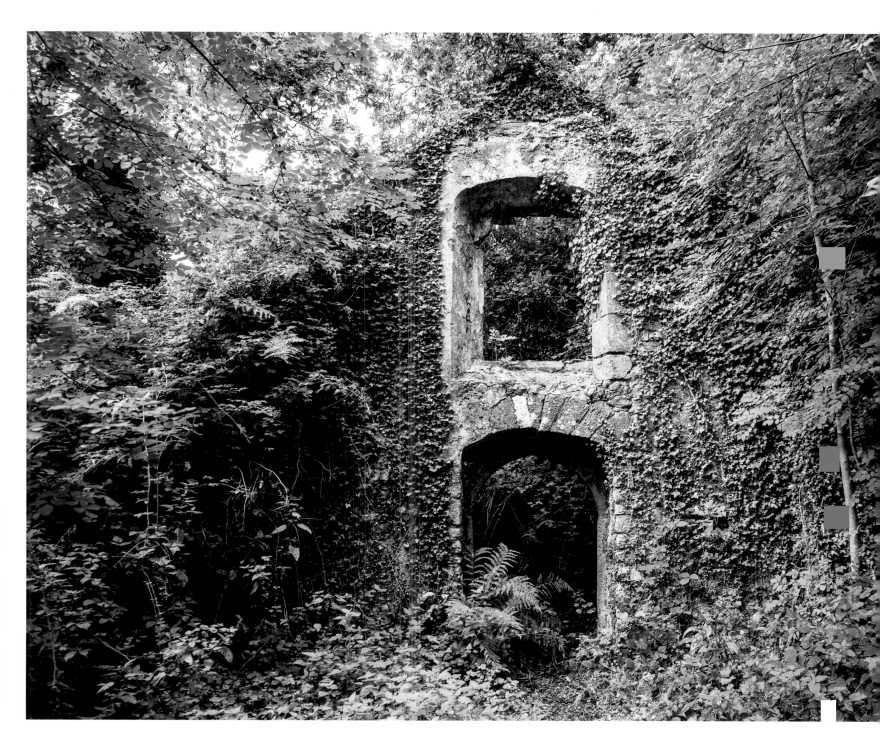

the deceptive green; a sunken path soon takes you upwards and then on the tops through gorse and heather, yellow and purple, and bushes loaded with red berries. Squeeze through a kissing gate, follow the track above the wide valley of a private estate. Take a narrow branch to the right and feel the crumbling flint beneath your feet and the prick of gorse tight around you as the narrow footpath descends sharply to a grove of young oaks and into the ankle-testing incline of a final field. You feel a certain 'story' in these paths, but the order of it, rightly, does not reassure you. You see no one on these paths; you feel the disconnection with the ancient here. The old has its own life, far away from museums.

Just before the notice that warns you against going any further there is an iron gate. Push it back and tread carefully, the ground is waterlogged, there are remains of rotted logs underfoot and the thorns of a leaning bramble push at you with sharp points. Use the poles of the cast iron fence to steady yourself. Then let yourself in through a second iron gate, squeezing carefully through the rusty entrance, in to the ruined chapel.

Ahead is what remains of a 'doom wall'. There is little else. The other three sides have long gone. The stones were distributed into nearby barns and farm buildings; violence to the old ways. There's a story told here of a photographer who visited, and whose prints of the ruin revealed a complete building; of course, the photographs disappeared. The soggy floor of the chapel is overgrown with briars, nettles and ferns which cover the mouth of the well in the chapel floor. Instead of being able to access the actual opening to the well, the very few visitors here must satisfy themselves with a tale of a tunnel accessed through the well, of hidden loot, of concealed treasures threatened by raiders, of escape to a distant cave. Everywhere there are these stories! Yet rarely do readers seek out the tunnels they read about. As if they would rather hear the stories than explore the real caves. As if the journey in a story can replace finding a real thing whose location has been forgotten by everyone else.

Mourn the overgrown well.

This is the first of a series of lost or ruined places you will pass through. In a moment, put down your book, consider how to prepare yourself for disappointments, setbacks and how you might respond to the shrinking chinks of opportunity the lost places afford. Prepare yourself.

The Granite Railway and Learning from Spaces

You walk for an hour, through the metalled lanes, between high hedges. On the edge of a village, a granite plaque has been set into a wall of limestone slabs. The chiselled text is barely legible, but you feel it out with your fingertips, it tells of a great storm that blew down the house here. Through the open gates, you can make out a broken wooden Temple of Venus on a green lawn. It was once painted white, with elegant pillars; now there are dark gashes in its tarnished paint where rotted sections have fallen into the clipped grass.

Further along the road, to the side of a cottage, is a set of stone steps. There must have been a building here once, a barn perhaps, but it has gone now and the steps lead up into the sky.

The useless can take you somewhere new.

On planes, ferries and similar functional vehicles, you already know where you are going, but a broken route can lead you to a precious, unpredictable 'nowhere'.

In the trees beside the path, almost completely hidden in dark green shadows, is a modern 'water temple' of thick concrete slabs and pillars. Its solid structure blocks, dams and

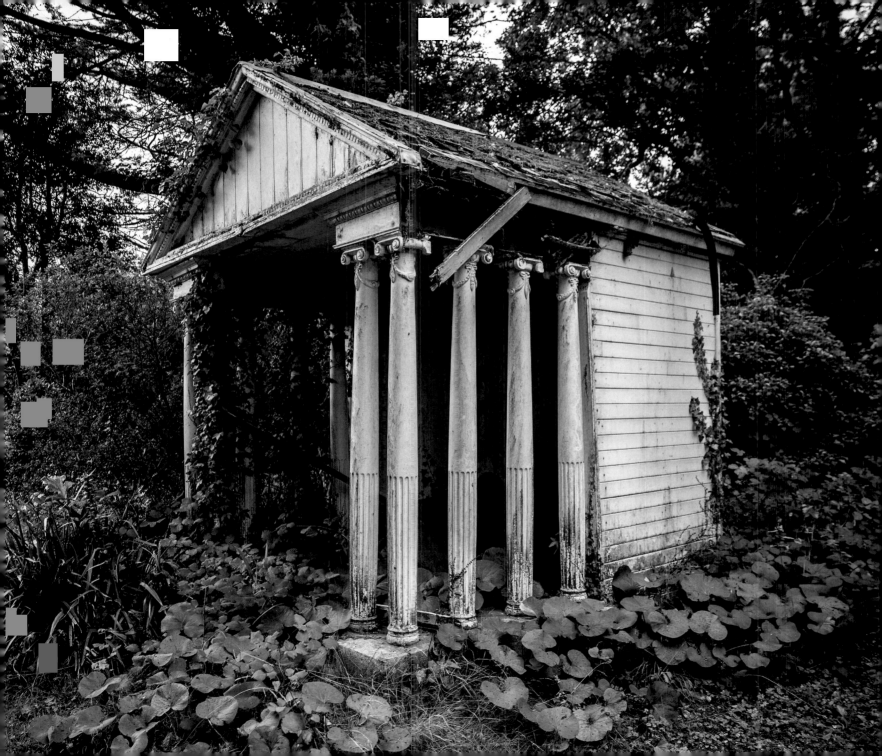

evens out the flow of rain from the hills. Water creeps around its greyish-white surfaces. Green algae tint the edifice. You know it is a modern device, an ameliorating machine for temporarily slowing and diverting the consequences of climate change. Yet its greened abstract architecture gives it a feeling of ancient malevolence; it is a toad-like thing squatted in the shade of thick tree cover, waiting patiently for a sacrifice.

Move away. Not all spaces are benign ones.

Not far from the 'water temple', beside the stream that tumbles from the concrete edifice, there is a generous gathering of bulrushes, a reminder of faithfulness, connection and escape and of the three stone angels in the churchyard. Bulrushes grow to the same height as a person; here their heads have turned brown and will soon release their seeds in great billows on the breeze. For the moment they are bound tightly in their tubular brown clusters and they nod, sagely, gently bending their stalks. As if swaying one way, before gaining momentum in the other. Consider how you can go a long way forward by starting with a resistance in the other direction: first go a little way back, then push off the other way.

There is much that is helping you that you never see.

Following the stream onto lower ground you find the bed of a now dry canal; its stone sides rise up from a dried and cracked clay floor. Alongside the empty canal basin is a set of old and disused railway tracks that end here; unlike the usual wooden sleepers and iron rails, these tracks are made of granite. They stretch up to quarries on the moor from which the granite was taken to build huge parts of faraway cities; the same granite used to make the tracks on which it was transported.

Imagine kitchen sinks carried on tracks of porcelain, or candy bars on rails of liquorice. ❖

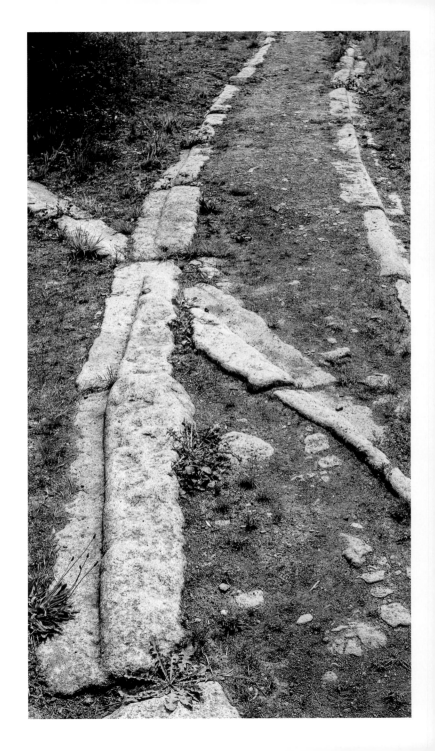

DAY 12

The Stonemason's Yard and Walking in Limbo

FOLLOWING THE DRIED BED OF THE CANAL, the towpath takes you towards the edge of the city. Over the hedge and across the fields to your left are distant buildings of a forensic psychiatric facility; tiny figures of patients, staff and visitors walk about the grounds, others are confined behind the tall steel fences of a high security wing. Inside a wooden bus shelter at the gates of the facility, on the road that rings the city, someone has drawn in chalk a huge flower: a thin stem, two almond-shaped leaves, and three overlapping round petals with a huge eye drawn within the topmost circle. The chalk flower is rooted in a bed of Special Brew cans, pizza boxes and cigarette butts.

No matter how abject, no matter how wasted the ground, an idea – with a sensory organ at its centre – can grow.

In the small industrial estate made up of old, mostly repurposed, brick warehouses and workshops, at the end of a narrow alley between high walls, at a mason's yard the taciturn and generous stonemason pulls back a piece of metal fencing, scraping it noisily along the ground, and allows you in. Enjoy the profusion of veined marbles, polished granites and soapstones, a single lonely and discarded classical column, the anxious face of a stone mountain lion obscured by bricks, cracked wooden pallets and a broken plinth with only the sole and toes of the statue remaining.

Imagine vanishing.

Imagine your raw thickness; your rocky fleshiness, your great slabs of muscle, your anxious bones peering through curtains of sinews, your marbled veins, the whole plethora

of your walking being. Walk on like the piled treasures of the mason's yard; walk rough-hewn and walk polished. Glory in the minerals of your body: salt, carbon, zinc, chromium, nickel and gold. Walk like a cliff, walk like an ocean floor.

Beyond the industrial estate, through roads dotted with large suburban villas and long terraced streets, you arrive at a funfair on a stretch of green.

What if this was everything?

What if this was the universe?

The rides are shut down and the sideshows and stalls tented up. There's an unnerving indiscriminateness here. A 'showman' approaches you; he's one of the crew who erect and disassemble the whole thing; he catches you having a 'deko' at his 'gaff'; he wants to show you how beautiful the painting is on the Ghost Train. It is beautiful; the artist, dead, was an artist. Unlike the Hollywood action movie celebrities whose airbrushed images 'grace' the Shooting Gallery, the Ghost Train subjects are neither representations nor from real life; but from some limbo in between. This is the terrain of a rough and rigorous art, detached from its referents; it floats free into a wooziness inaccessible to exploitative curators or snobbish critics. It is an art on its own. Like you.

Limbo is not an easy place to be. There is no easy way to move forwards or backwards. Fun is a disturbed house: ghosts are travelling on a train, murder is hung in a gallery. The shuttered stalls look like confessionals and the bright afternoon feels like darkness. Inside the 'fairground' there is neither a base nor a fundamental ground of being; hang on to whatever subjective conviction you can find in yourself right now, this is a test, an ordeal of self-belief, the rollercoaster is the scare ride of the soul, without community or identity to hold your hand. You are alone among the rides and stalls.

And they are empty.

Whatever you can find in yourself here is real. Cherish any small things – put down the book and count them to yourself – and do not despair; relief and refreshment are not far off now.

Café, Chapel and Freeing Myth from Story

Order yourself a coffee; or whatever your regular drink is. The café is vegan.

The decor and furniture, perhaps surprisingly, are neat and functional, like that of a newly refurbished school rather than an ethical eating place. Modern, but not mannered. Sat at various tables are a young couple, a small child and his parents, and a slightly formal gathering of elders sharing anecdotes; perhaps a memory club?

Enjoy the quiet ordinariness of the place, then turn your attention to what lies beyond the rail.

This is not ordinary. A black metal fence, waist high, separates one corner of the café from the rest. Take in the rather bemusing mural of a bigger-than-human-sized rabbit – something self-deprecatingly ironic to do with the vegan cuisine – at the back of the fenced area; while the proportions are as in nature, in the confines of a small café the overbearing effect of the painted beast is as if you are unwillingly starring in one of those movies where the human characters are shrunk and cuddly mammals become giant predators.

Beside the paws of the towering rabbit, the stones painted at the base of the bucolic mural abut real stones and pebbles that cover the floor behind the railings, along with both plastic and living flowers in pots, and comic plastic toads and ducks, all clustering around an octagon of real old red sandstone

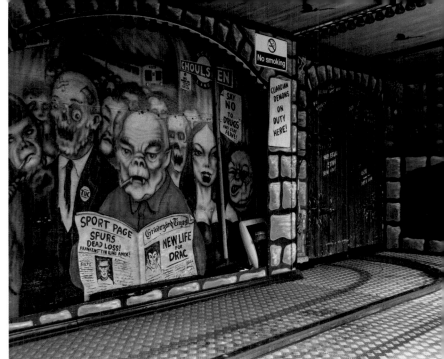

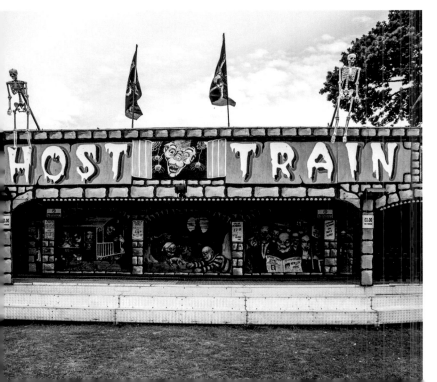

blocks. In the centre of this sandstone octagon is a black plastic bowl half-filled with water; coins glint under the water. Savour the gaudiness. The well may be no more gaudy than it was in its medieval heyday, when pilgrims visited in large numbers for the healing waters.

Sip your drink. Consider how the black bowl plugs the mouth of the ancient holy well. The note on your table explains that the spring which feeds this well first began to flow upon the martyrdom of a saint right here. In some tales she is a Saxon heiress decapitated with her own scythe by labourers in the fields. In other stories the spring is a magical flowing of a 'Celtic water goddess'. Stories are not told the way they were two thousand years ago.

Stop thinking in the usual way.

Let name, memory, job and family fall away for a while. Just look. See your hands on the coffee cup. Your legs beneath the table. You cannot see your head.

Let that go.

Leave space for the cosmos to rush back in. A vacuum for tiny and giant things to inhabit. Free of 'I' for a moment, celebrate just how things are. Without a head to prevaricate, abstract, anticipate or countenance, you-can-be-now. Which is not the be all and end all, but it is a rare place to really be.

Let that sink in.

To lose your head is to become a great pilgrim; not a walker wandering in space, but to be part of space.

Finish your cup, leave the café and follow the road to the High Street, where a giant sculpture of the saint hangs above the shops. Here, among the rush of shoppers, distracted by the passing of double-deckers, is the holiest place to be right now. Although made by a modern artist, the figure of the saint follows medieval conventions: the goddess-saint, a starburst

from her head, has a dress like corn, a scythe, a spring bursting from stones, water shaped like so many eyes, and a watered tree with curling boughs that flower. The different parts of the myth lie along the almost-flat plane of the relief and hover, as if they are orbiting each other. Allow the scythe, the corn-like dress, the spring bursting and the city wall to float about each other. They make their own meanings. Float with them. Be just another object in the myth.

Beside the sculpture is the path up to a church dedicated to the saint. The building is mostly now a community centre, but the generous manager will take time out to lead you up a flight of stairs to an upstairs chapel. Among the relics is a rescued

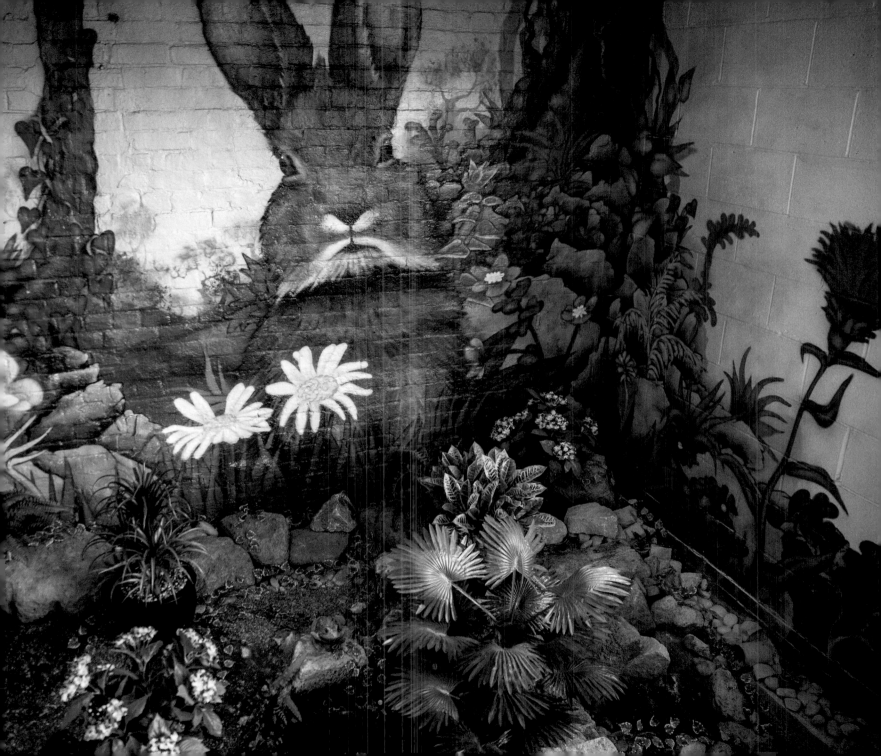

Victorian stained glass of the saint, while behind the altar is a giant modern stained glass of her martyrdom. Observe the fine detail of the Victorian glass with the scythe, disturbingly, swinging down on the saint-goddess's neck, while beside her the spring has already begun to run. In the modern glass, the obligation to explain the miracle is greater and not only do we see the murderous labourers egged on by a jealous stepmother, but the stepmother egged on by a purple devil with wings of green leaves. Even subjection to narrative – trapping the artists in misogyny – cannot fully repress the surplus of the miracle and it spills out in the gushing and curling forms of spring water and riots of greenery.

The power of myth – different from 'fairy story' with its jealous stepmother and whispering devil – is to give us all possession of the void that leads to everything else.

Thank the generous gatekeeper who has let you in. You are an unusual visitor, you are a welcome kind of thief; harming no one, subtracting nothing, your mischief adds to the wealth of others.

Return to the High Street and stand, again, before the sculpture hung above the shops. Let the parts – scythe, water, you, tree, wall – once more orbit each other in their own galaxy of meaning. Then add other passing things: bus, pedestrian, a bag of shopping, fallen leaf, shop sign. How much can the myth hold? Add as many things as possible; if the myth breaks down, subtract some of the things until it tells itself again. ❖

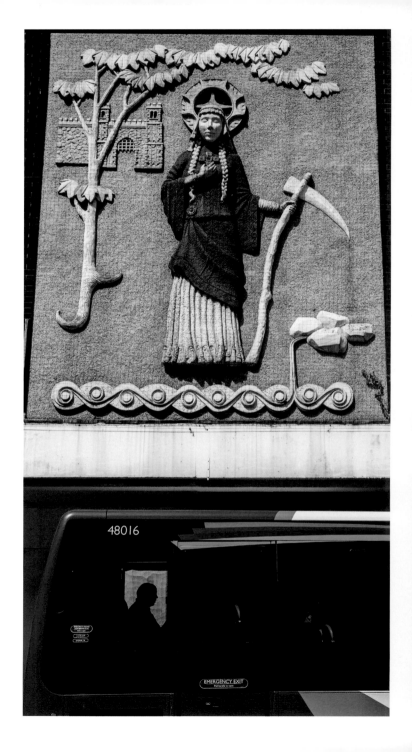

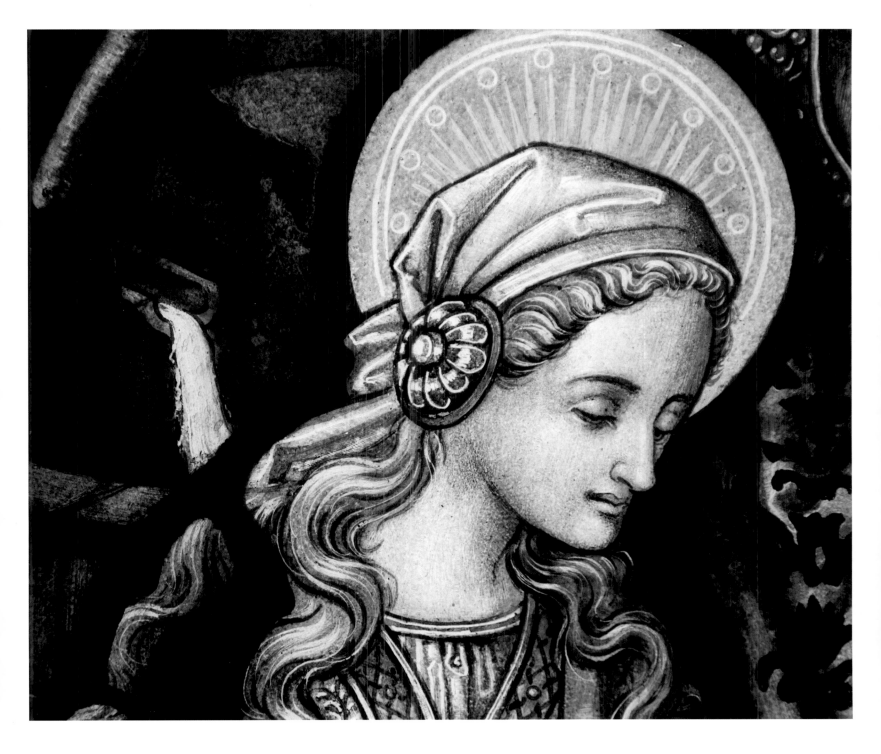

DAY 13

The Reassembled Chapel and Time Travel

Exit the city; just beyond its edgelands is an old priory, built by frightened brothers and sisters who had once fled a revolution. In the quiet margin of the countryside, they built themselves a high wall and escape tunnels.

Despite the grand church that once housed the hair shirt of the saint who coined the term 'utopia' – or 'no place' – for an earthly heaven, you can ignore the history of deconsecrated buildings converted into retirement housing and take a path that follows the tall boundary wall into a copse of cork oaks and dark trees.

The chapel in the tiny wood is like something from a fairy tale; a bright shining cheap thing made of corrugated iron and painted luminescent Mantis green, purchased in a kit and assembled over a century ago. It has the kind of glowing beauty that might attract a lost and hungry boy and girl with promises of gingerbread and a hot bath.

But, inside, the hag is beautiful. Open the door gently and let the light in. There is a single chair; sit there. And look up to the radiating blue lady, a thorny rose stem under her foot, a spring bursting bright blue beside her pink toes; not a statue of the lady, but a statue of a vision of the lady. The numinous has been plastered. Sit back in the seat and let that paradox wash over you.

Reach through the veils.

A stained glass window above the sculpture has the same three overlapping circles as the chalk flower with the large eye in the bus shelter.

The walls are decorated with cork tentacles.

It was not always this way; the pieces of cork bark once represented rocks in a tableau representation of a famous grotto. The tableau was dismantled and its parts are now hung on the chapel walls, the latest in a series of seismic shocks that transform the scenery in corrugated ritual places: heads are removed, one thing stands in for another, bright mesmerising colours are whitewashed, patterns are replaced overnight by text, psalms are silenced and then cranked up again, local miracles are disseminated between continents.

Contemplate this wholesale reassembling of the parts of reality; how one generation makes a new thing from the precious things of a previous one. How the meaning of the cosmos is in continuous upheaval. Why what declares itself for ever or for everywhere can neither be trusted nor believed in. Such a 'truth' is depthless. The preacher speaks the miracles rather than the miracles speaking the preacher.

In this chapel of metal waves, feel the great shifting of mental and cultural architectures. Feel how such grottos are dismantled, their waymarkers uprooted and placed in foundations, how holy pillars are uprooted and put to work holding up the cellars of the wealthy. And revel in the survivals here; how the snake is still in the thorny stem, the grotto still echoes in the writhing cork walls, how the alchemical magic of ancient smiths (when all engineering was supernatural) is still evident in the assembled metal church.

Find your own truth in the stiff chair, in how you respond to the carvings of water and thorn, to the tentacles of cork and to the three overlapping circles with their missing eye.

This chapel is a time and space machine. Seated in the stiff chair, before the altar and its repainted statue, you are sat at its controls. Put down this book and, for as long as you can, travel wherever you wish.

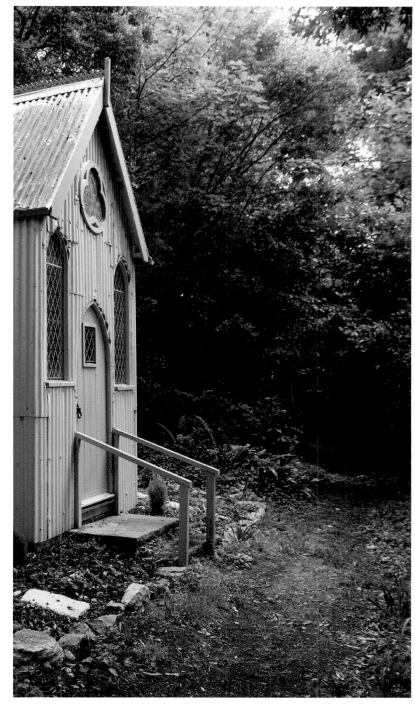

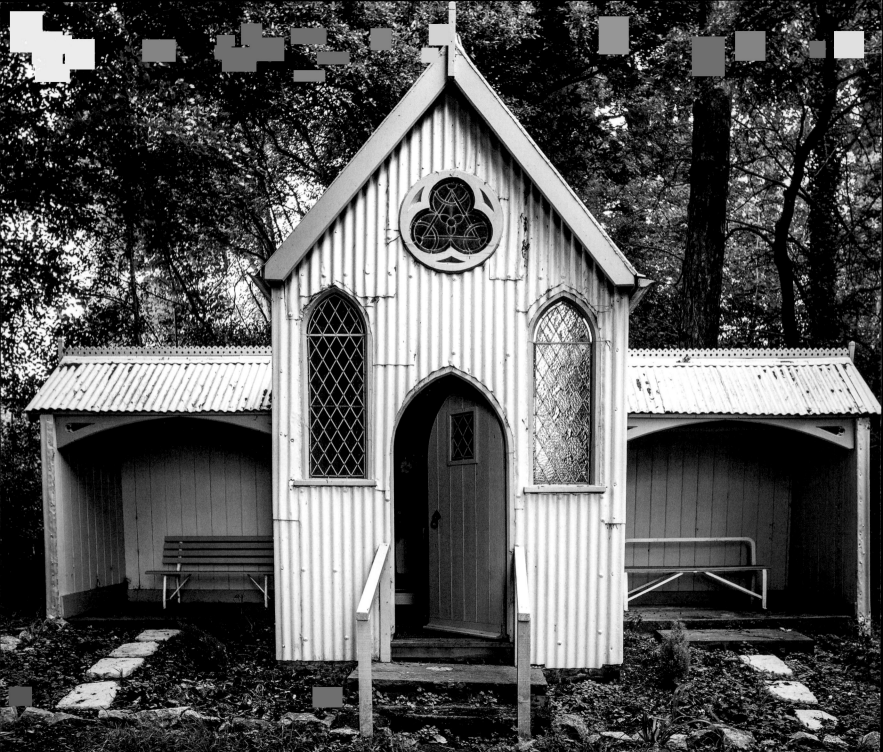

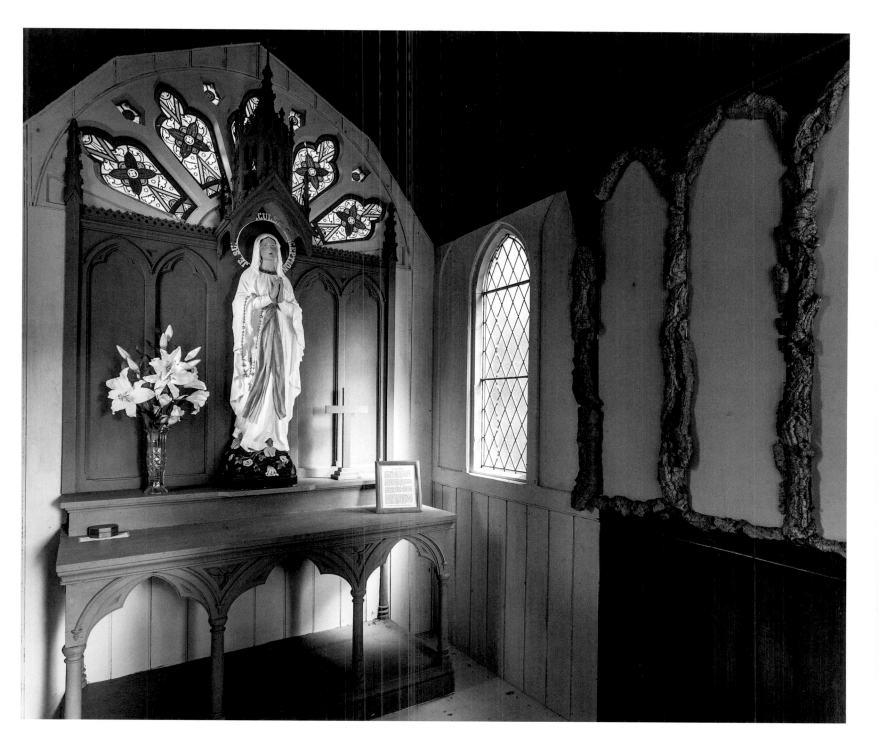

The Broken Statue and Joining the Chapel to the Sea

Outside, behind the chapel is a broken statue; it is the dark shadow and guilty memory of the shining blue statue within. The head, shoulders and most of its chest are gone. Mysterious lumps of raw iron and a hammerhead lie at its broken plaster feet. The patterned vestments of a male priest are still evident in the trashed sculpture. Perhaps this was an image of the saint who had his relic here, who diffidently dreamed of a utopia on earth, of a universal and absolute plan that would repeatedly manifest with scapegoats, exclusions, massacres, walls and coastal defences.

Contemplate the ruins of an absolute utopian universalism that forces local truths on everywhere and wonder what–if anything–might be built from their parts.

Turn away from martyrdom, coercion and persecution.

Turn inside. Find in yourself the flowing spring, the snake-like water, the tentacles of anomalous materials. Feel the rose stem under the soles of your feet, feel the spring water run across your toes, relish a meeting with a woman who, scandalously, made love with god.

Look back–the door of the chapel is still open–but the inside is changing.

The scythe is the rose is the snake's tooth, the stained glass lantern is the solar halo on the high street is the overlapping petals of the chalked flower; the streams of water are the rubbish in the bus shelter, are the sheen on the green and purple serpentine dragons in the church beside the three angels ...

Lose your head for a moment; everywhere is welcome.

Do not move, but allow your mental space to return inside the tin chapel, to become the chapel's insides; feel how cave-like you are now. How–like in the museum store room–furry hyenas surge around in circles inside you. Weave them in a halo around your head: rose stem, stained glass circle, water snake, stream and the pattern of hyenas' teeth across the rumpled velvet of a vitrine. Whirl together with them.

Take a moment to be giddy.

Something in the deep, something far away and yet so close in all these places–pub, chapel, café, cave, store room, shore–is stirring; something that links all these places with the suckered tendrils in the secret garden. ❖

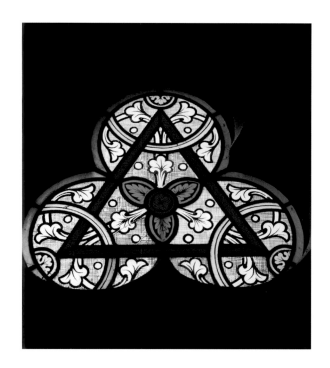

DAY 14

The Old Church and Vainglory

FROM THE TIN CHAPEL you head out along more deep folded lanes and across the commons towards the Great Hill once more. Beneath the hill you see a church, its white spire gleaming against the dark green oaks that line the valley.

You approach the porch. To the left, on the ancient render, the faint trace of a tentacled creature. You feel its outline with your finger as Thomas was said to have traced the wounds of Christ. Do you still doubt? Do these things – the goddess of the deep, symbols in the air, intuitions of the ancestors' presence – truly exist, or are they just a parable?

You stand in the porch for a while. Above you four faceless angels are fixed in the stone tracery. What violence is here! Imagine the order being given. Tools collected and carried. The placement of steps and then the knock of hammer on chisel and the fall of stone fragments of faces. What were they thinking, as they chipped away at a nose, then an eye? What dismal theology is it that inspires such acts? And why just the face, while leaving wings and vestments intact? So that we should not look on too many faces of God?

A bat is hanging from the porch ceiling, dark and soft against the chalky whiteness of the stone. For a moment, the two of you – a mammal pilgrim and a mammal that can fly – catch each other's gaze.

You lift the latch on the heavy wooden door and enter the church. It is airy and spacious. And as white as the tower outside. Empty pews fill the nave. Each is a wooden box to enclose the laity. You imagine the congregations here, picture the imaginings that these benches contained. The flights of fancy taken as folk's attention wandered from the mass. Dreams of love and loss. Matters mundane. Occasionally a word or two might cut through from the pulpit. A sermon demanding attention. But mainly the people made their own services, told their own stories to themselves as they sat quietly and dutifully before the altar.

You sit in the pew closest to the pulpit. You look up at the great rood screen, the separation of heaven and earth, a clear and unmistakable boundary across which none but the elect shall pass. Beyond, through the fine wooden arches and heavily carved beams is the altar, and above it the brilliantly coloured glass of the east window. Is that what a heaven is? Will you ever pass through those gates? Do you want to?

You look at the doors, and on their screens are two painted figures. On the right door is God, painted in full attire, an old man with a white beard dressed in the apparel of a monarch. On the door to the left is Mary, clothed in red as scarlet woman. God holds a small golden crown and reaches across the doors to his lover to place the coronet on the red Virgin's head. Things are mixed up. This coronation can only take place when the doors are shut; and is undone each time admission is granted. What kind of magic is this? Magic that reveals by shutting out? What kind of medieval Hollywood? Where Mary can only be made Queen of Heaven when her people are shut out of her sanctuary?

The Chancel and a Time When Things were Local

Either side of the red lady and her lover god is a constellation of saints, each one occupying its own panel. Each of these is crudely painted by an unknown hand. There is no narrative in any of these images. Figures and objects are pre-

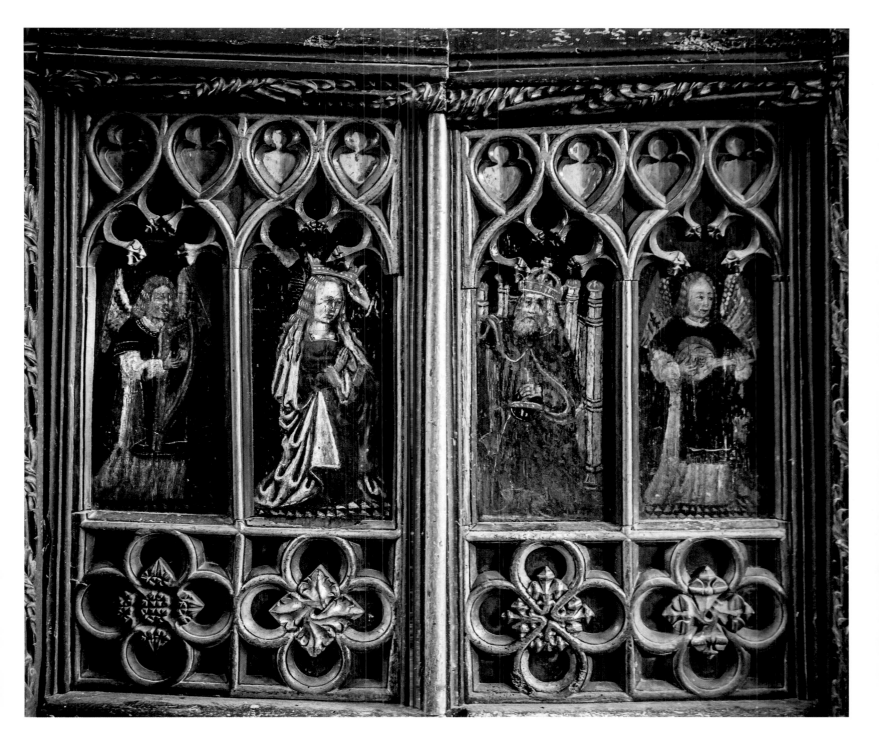

sented outside of time. The key to each saint's significance is in the things they hold or wear. They are defined by things; without the domination of the word they are endlessly open to interpretation.

Each of the faces of the saints may have been modelled on that of a local person; each one known as a friend or relative to the congregation. Here, holiness is next to neighbourliness.

Imagine the stories that might have been created here, by idle minds in endless masses on long sabbath days. "That isn't St Margaret of Antioch, it's Aunty Rose, she had her own dragon you know, used to keep it in the shed and feed it turnips." "This isn't St Victor, it's old Enoch the miller and that's his windmill." "That isn't St Philip, it's Uncle Richard, the baker, see the loaves there, look!" "This isn't St Dorothy, it's you, my love, with a basket of apples and roses."

But when needed, each of these malleable characters could help to heal. For toothache, appeal to St Appolonia there on the right; see, she holds a tooth. For wounds, fashion the injured part from wax and offer it to St Ursula that she may take your pain as she bears those arrows that pierce her flesh.

Here, in this place, on the dividing line between heaven and earth, the word floats free and disappears. Time moves back and forward and around. Meaning is not fixed. There is nothing necessarily universal or orthodox in these pictures; they can mean so many things. Each is a reflection of the local, and of that which the common people bring to the uncommon invisible.

Only with the men bearing chisels, and bibles in English, did this change. Then things became what we were told they were; told from afar and fixed in text. 'Local' came to mean 'less' and 'unconnected'. Things became singular, antique, decided. And in this change, there was a flattening. Not of the world itself, for the world itself is forever and everywhere uneven. This flattening was of us. It was we who lost dimension and depth, our meanings and bodies restricted and our minds bound in the lines and curves of letters.

Look at the words on this page. Do you just see the ink? When you follow meaning do you point at the letters with your finger? This is flattening. The unevenness we seek can be found in the space between and around and above and beneath the letters, where nothing is fixed and nothing is bound by ink. Now, unflatten yourself. ❖

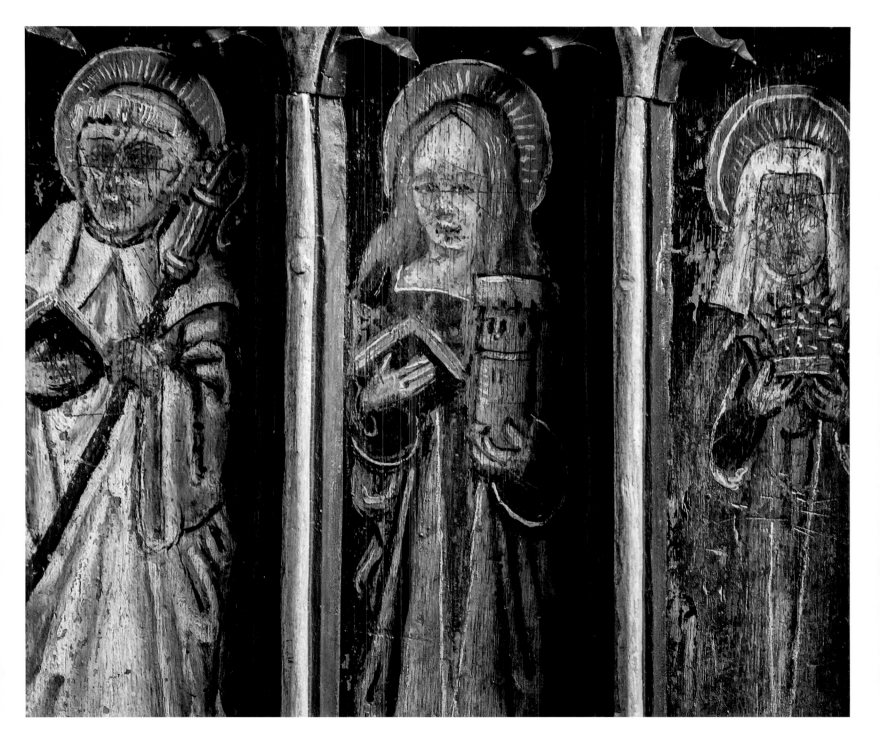

DAY 15

The Wrong Hill and the Botching of Creation

STRENGTHENED AND INSPIRED by the things the recent 'days' of pilgrimage have brought to you—journeying from the church of the three angels via prison, granite railway, water temple, stonemason's yard, funfair, vegan café, metal chapel and the local saints of the rood screen—you have a sense of truths running parallel with official creeds. You intuit a local symbolic belief in which local people and local places and lo-cal fauna are holy and symbolic. Inspired by these thoughts and impressions, you are ready again to find and climb the Great Hill that has been calling to you ever since you were in the deep.

You are soon climbing upwards, but this…this…may be the 'wrong' hill…

Nevertheless, enjoy the climb up to a tower on the top. A few Devon Reds are dotted about the fields, chewing grass; but it is the placing of large trees in the fields that you should focus on next.

Enjoy the shapes of these mature 'ents'; oaks mostly. The generosity of their bulbousness, and the elegance with which some stand alone in pleasing proportion to the curves of the land, while others are grouped as if in quiet conversation.

As you climb the hill, notice how relations here are 'easy' on the eye; gaps between trees are as engaging as the trees themselves. This might almost be a painting of trees in a landscape rather than real trees in real fields! Sit down under one of the oaks and consider the view. Can something be both real and a representation at the same time?

This is.

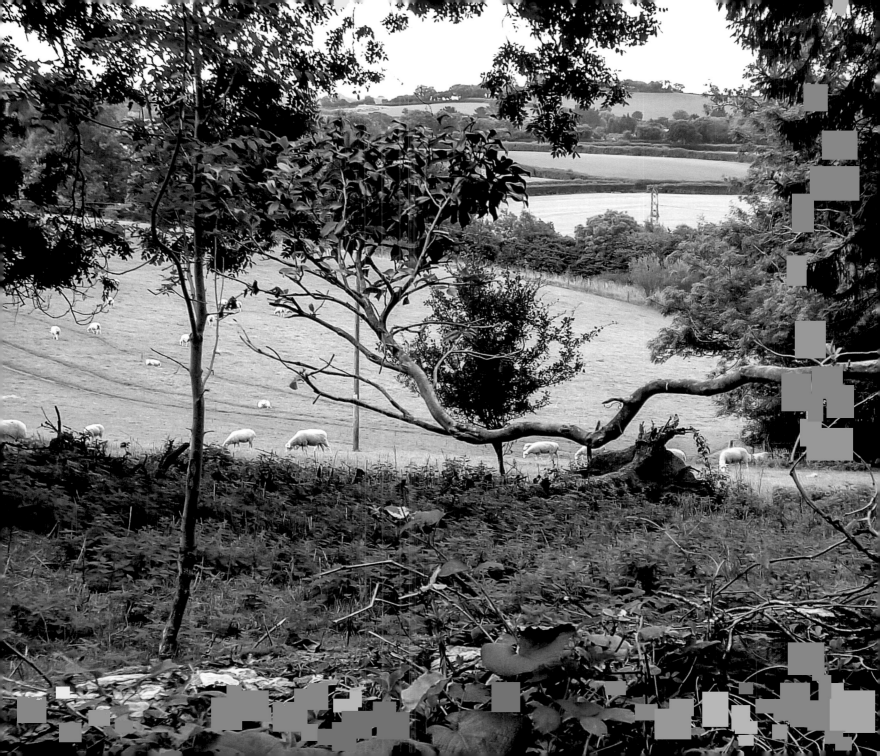

For the trees are what remain of the landscaped grounds of a manor house; even the recent hedges, planted for practical reasons, cohere to certain principles of line and proportion. Enjoy their happy geometry. Still in the shade of the tree, walk the hill in your mind, climbing through its layers of eruption, weathering, evolution, the intentions of farmers and designers, of decline and pragmatic addition; give each one a little time.

Then walk it again, but this time walk as if you could walk in all of the layers simultaneously. Then, cast your shadow, and walk beside yourself.

Consider the unevenness of being; how a 'botched' creation – with worms that burrow into the eyes of children, or tsunamis that consume the lives of the unsuspecting – does not require contrived explanations concerning the sinfulness of victims or the redemptive effects of suffering.

Creation was neither a cruel nor a benevolent mishap. Imperfect wrinkles in the plasma, a nano-moment after the Big Bang, were already defining the clumsy structures of the cosmos; later imperfections gave rise to the grass you sit on, the shadow of the tree that cools you from the unnaturally fierce winter sunlight, the elliptical orbit of the planet, and our spiral arm of the wonkily beautiful Milky Way.

Climb the hill for a last time; this time for real, this time very slowly. Allow each part of the terrain – cows, hedges, dragonflies, mud and dust, and the distant granite tors – to impress into you the holy presence of accident. Walk without destiny or happy ending, in a world that is not like light entertainment and mainstream movies, but a cosmos of confusions and adjustments, of unintentional injustices despite your best efforts and unintended fairness despite your worst – walk in a countryside where 'shit happens', but 'beauty happens' also.

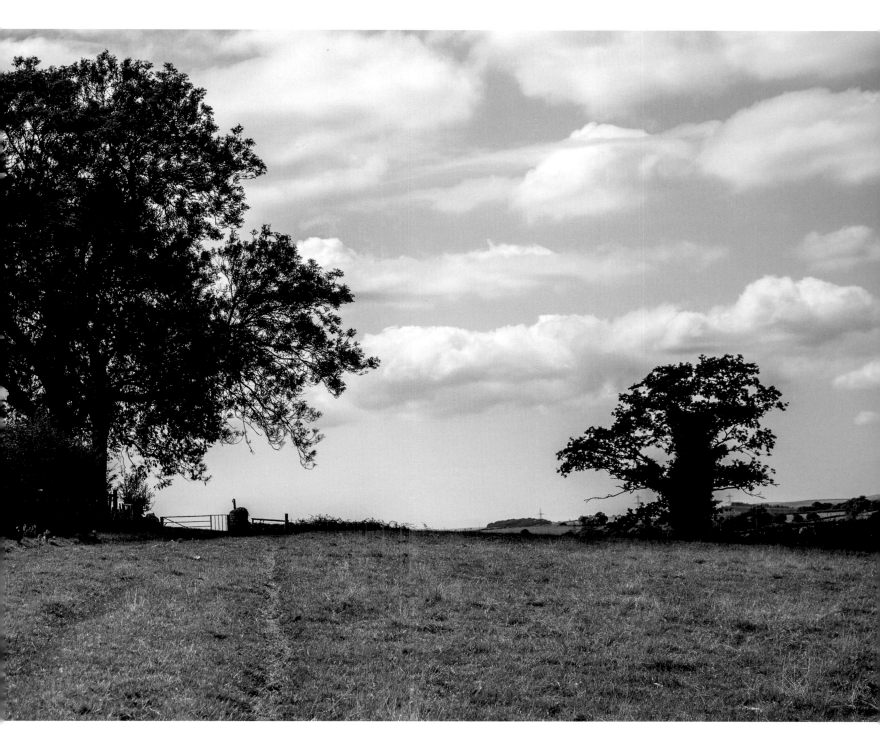

A Broken Branch in the Chapel and the Parallel Faiths

At the top of the hill, climb the stile into the neatly maintained graveyard of a small deconsecrated church. In the churchyard you are greeted by Whistler, dressed in boots and shorts, who tells you that he sometimes sleeps among the graves he tends. His gardening tools lie in the grass at his feet. He describes his visions of nuns and of racing black shapes, and of a symbol descending from the morning sky like an upended horseshoe both ends of which turn up and then turn down again. Whistler crosses himself and swears that this is the truth.

Why, here, would he intuit a floating symbol of a cephalopod?

Inside the chapel you find that, right in front of the Christian altar, the chancel has been decorated with a lichen-covered hornbeam branch that glows in sunlight falling from a window. You had already noticed the huge shape of a fallen hornbeam outside in the graveyard, blown down across the headstones by a storm. You suspect that Whistler may have placed the branch here as a gesture of his 'parallel' faith and devotions; not as a dissent from conventional beliefs, but as an expression of the local and subjective beliefs that live alongside them. An echo of how things were maybe worshipped here before they were fixed by text: spontaneously, intuitively, more guessed and more felt than learned.

Another hand has been at work. An acorn has been hung from a twig on the broken hornbeam branch, secured with coloured thread. Among the pews you find reels of cotton in red, blue and white; another sign that a 'parallel' and a local spirituality are, for some, returning … that you are not alone in making a journey like this. ❖

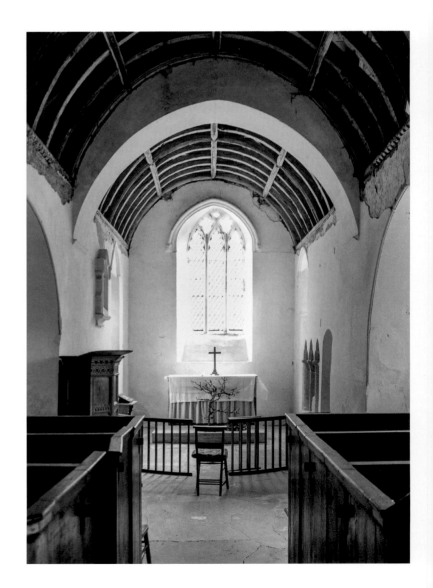

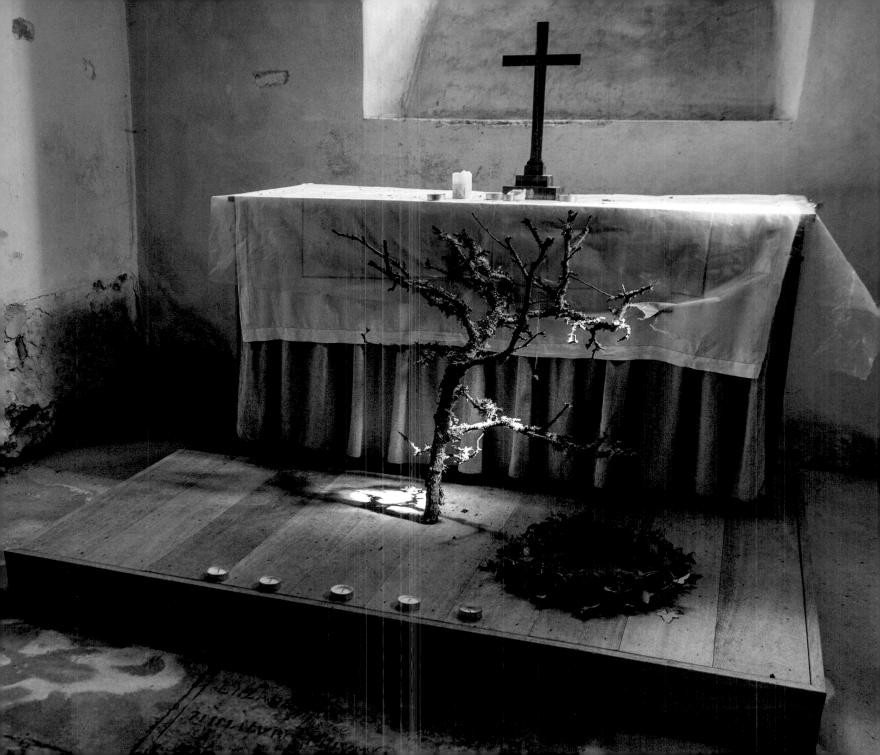

DAY 16

The Top of the Hermit's Tower and the Depths of Despair

JUST ON THE OTHER SIDE of Whistler's graveyard is the meditation centre, housed in a building of many pasts: a manor house for Tudor gentry, a military hospital that never opened, a retreat, and then the home of a monastic order of Sisters Superior who named rooms after saints and 'The Cloud of Witnesses', until the building assumed its present function. It is another place where the layers are exposed like the map of the museum.

You have heard of the house's 'Hermit's Tower' and the thought strikes you that this might be your 'Great Hill'; not the green hill crowned with trees but a tower on top of a hill, the higher than highest ... that perhaps this is the secret you seek, that the dream you treasure is up there in the belvedere.

You smile at the parking space marked for 'Gaia'; it seems unlikely. Are there still goddesses here?

The friendly administrator invites you in, and you walk quietly among the guests arriving for their seven days of silent meditation; they converse gently before their silence begins. You sense immediately that you may have misunderstood your pilgrimage. What seems to be the Hermit's Tower, round and old, has no staircase to climb, but is made up of unconnected storeys. You feel the disjunction. The interruption of something when the layers do not connect.

Perhaps sensing your frustration, the administrator leads you along worn stone flagged floors of local 'marble', pinkish and fleshy, down dark corridors, to a beautiful staircase ... unexpectedly! This is it! You climb its symmetrical serpent, up past

doorways to wings named after the Great Hill and the tors, but, when you get to the top there is nothing but a feeling of vertigo, of fear and the desire to plunge mixed together. The formal winding climb into a blinding but unilluminating light has made you feel ill at ease with the aspiration itself.

Imagine in the dazzling light missing your footing, falling head over heels to the bottom of the staircase, unharmed but embarrassed, your fall disturbing the retreat members. Hear their gasps as they see you hit each step.

Then something happens. You are not in the well of the staircase at all; you are in the darkness of the well in the floor of that ruined chapel high up beside a distant valley that you approached through gorse, kissing gate, grove and over flints. You have fallen through the floor of your own journey, you have fallen through a mesh of stories about madness and robbery and treasure and invasion; you have 'got to the bottom' of a legend, and there is only darkness. Somewhere far away you are apologising to an administrator and preparing to leave a building, but at the bottom of the well is where you feel you are; is where you hear the politeness and rituals of everyday life, the tales we tell ourselves and the codes we live by, fall away. You are stripped of language, now. The world that you know sounds far away, more like a dream or a movie playing in a far-off empty cinema, while all around you, what is intense and very much here is the darkness, dampness and decay. You cringe from the mouldering lack of light; you intuitively know, despite all promises of treasure, hidden experiences and jewels of knowledge, that where you are now is what is most real in this terrain, that this is the truth your pilgrimage has brought you to: claustrophobic nothingness at the bottom of the well of a mad monk in a ruined chapel.

Is this pilgrimage a killing joke?

The Walking Room: Death in Life not Life after Death

In falling you have risen. The administrator is apologising to you. You feel the softness and smoothness of the cool flag-stones beneath your feet, you hear the murmurs of concern from the gathered meditators. Somehow you have returned from the darkness, you have been lifted up by gentle hands. Although the meditators and their administrator speak hardly more than a handful of kind words, you immediately know what they have understood. That the treasure you have sought is not a cache of gold or silver plates or even the knowledge of secret books taken from a great library and concealed in the well, nor great meanings hidden from invading Vikings and Vandals. Not even the wealth of realisations and intuitions you have received and found on your pilgrimage. Rather, the treasure is the darkness, the decay; the treasure is the death in life.

As the administrator guides you along the corridors towards the light outside, back to the green fields and bright lanes, you notice that one of the rooms is labelled 'The Walking Room' and you cheekily push back the door. Already ajar, it swings wide open and reveals a large room with a flat polished wooden parquet floor, ideal for perambulating; all along one side, backlit naturally through sash windows, is a rank of tall flowers, giant plants and potted shrubs, and at their centre, like the captain of a team, cross-legged, is a human skeleton. You let the door close.

Death in life, not life after death, but death right here and now. Irresistible and impossible to delay.

As you walk out into the sunlight, you are not quite sure how you managed to rise just as you had fallen; whether by accident, by your own effort, that of the subtle community of meditators, or thanks to a far greater force sending a strange squid-like structure to bear you up. Whichever it is, you have risen for sure, and you have identified the treasure for yourself: a darkness deep down from which good things come. A darkness that is as much inside you, and as capable of protection, as the bottom of a lonely well. Walking out from the darkness, feel the new life around you. Suck up the sense of who you are, step out into the green.

The ivy on the house salutes you. The hedges around the lawns, the trees down to the road, the fallen hornbeam in the graveyard; you are no longer worried by falling but realise yourself as an always dead-one-walking, in each step anticipating and welcoming your dispersal to the plants and earth. As you clear the trees, the hill affords you a view across the valley to the tors.

No villages are in view, but a few dispersed homesteads; the footprint of the ancient Dumnonii is right here. The structure that holds up all the layers since, this is a faint trace of an ancient people who were slow to make war, had no currency, did little to exploit local resources, and ignored the temple and city building of their Roman invaders, choosing instead to continue to give reverence in the streams and among the trees and to the deep. It is a landscape of dread feeling; a space that when you walk in it, you know it walks in you. ❖

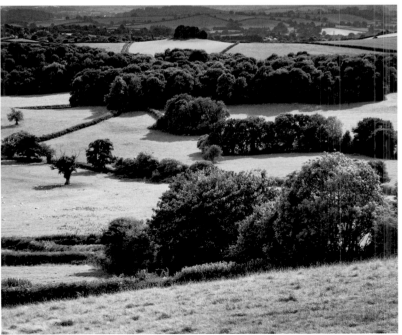

DAY 17

The First Cave and Its Second Darkness

FROM THE MEDITATION HOUSE, walk towards the valley, dropping down over uneven ground, paths studded with bricks of volcanic basalt and then, as you reach the valley bottom and make your way through woods, step over limestone chunks. The land is divided here; you walk with a powerful uncertainty. You have the permission of one farmer, but not another. You are in the flat plane of the valley, but not far within the trees you can make out a sheer cliff of limestone. At first you seem to have found everything at once! A cave's mouth surrounded by piles of stones, but not quite coherent enough to assure you that this is the ruined human-made structure you are seeking. You enter.

Tread carefully. Take time to look, allow your eyes to adjust. Check the uncertainty beneath your feet, feel for balanced stances that respond to the bumps in the floor. Examine carefully the walls and roof. There are odd shapes where acidic rainwater has dissolved the limestone walls and reformed them in tentacles; accidental sculptures made from limestone, formed from billions of dead sea creatures, their shells and skeletons sinking to an ocean floor 400 million years ago, and compressed under fearful pressures into stone. Now, they have made, once more, aquatic shapes; tendrils, feelers, legs, tentacles. They emit a gentle glow of impossible bioluminescence. A lustrous carnival of limbs dripping down the wall of the damp cave.

Eyes of stone regard you. Here you are within the tunnels of a labyrinth and with the senses to navigate it; in the cave the maze and its sensual map are woven around each other. Light

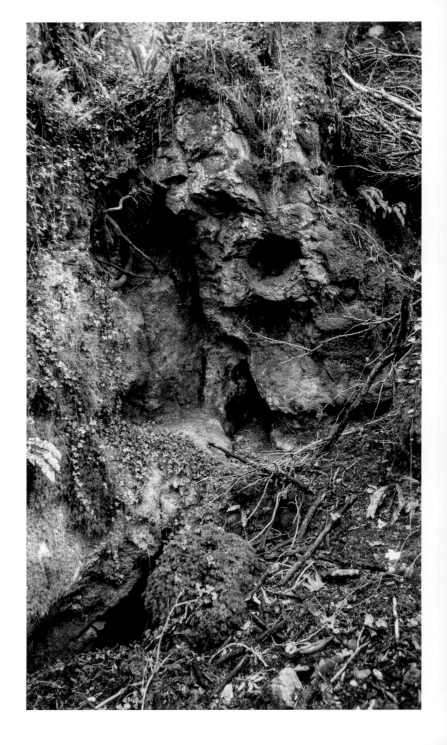

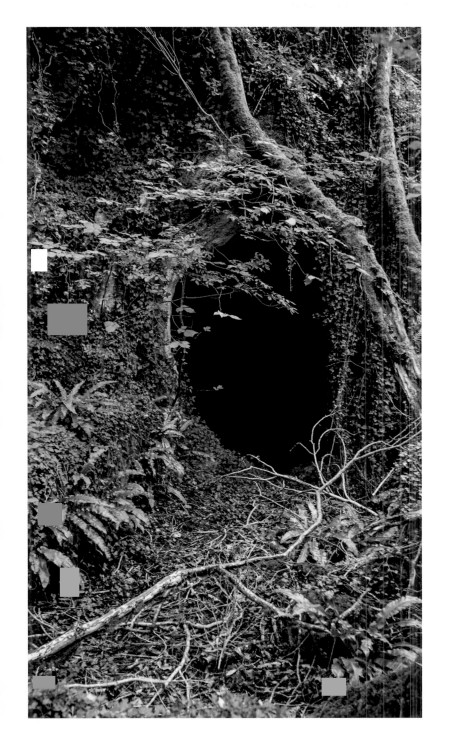

and eye entwine. Pause a while; sit down on the cold stone floor and experience the double movement of geology and physiology sliding like endless soft sleeves around each other.

Put down this book – allow the cool of the stone to clothe your flesh, allow the shiny stone tentacles to touch you.

When you are ready to take up the book again, move very warily towards the back of the cave, careful to avoid the dark pits that drop down to deeper caves. Examine the far wall. Emerging from its deeper darkness is a 'navigator', a limestone formation like a fossil of a long gone somewhat humanoid traveller, its protective helmet and trailing feelers is all that remains of it; the faint trace of barely conceivable journeys and wholly inconceivable sensations that came before yours.

Turn around. With your back to the cool rear wall of the cave, gaze backwards towards the entrance; a distant flat sheen of the brightest light, a screen that reveals little. Consider the dark pits you have avoided. Consider how you might drop down into them, carefully. Lowering yourself, handhold to handhold, until there is no screen of light, no cave, no hand-hold. Nothing.

You climb down. Take your time.

Stay in nothing. Reverence nothing. There is no gloominess here. Let the nothing of the cave meet the nothing of your within. Here you are at the nothingness-at-the bottom-of-the-well-of-the-self and it is still a thing! This is your work now, the cave has done everything it can for you.

Take your time.

Only you can let go of the illusion that at the bottom of your self there is anything at all. Even the pitch black cave floor is an illusion. Let it fall away and hang in suspended luminescence. Like stone plankton on the cave walls.

Then let even that fall away. No metaphors ... just a

luminous, entirely shining, letting-go.

Stay as long as you want; allowing tides of bright nothing to cross the strandline of identity and push it up the beach, then pull it down the beach again.

Without choosing, allow yourself to be lifted up, by a gentle inundation, without handholds, back into the cave. Climbing out of a second darkness – a darkness of light – there is still more to do.

Outside of the cave, you continue to follow the cliff wall, within the trees, clamber under a barbed wire fence, and trespass… Strictly speaking, you should not trespass, but what harm will it do? No one knows where you are, no one will follow you. You have the integrity of the lonely one, the wanderer.

Only by transgression can you reach the cave you need. There are some things you can only do alone.

The Old Grotto: Reverence the Past and the Past Reverences You

Freed, a while back, from the idea of a heaven after life, two wonderful things have now begun to happen: a 'death' in life becomes a means to an inner mutation and you liberate 'ghosts' from being things to be feared or hunted so they can realise themselves as 'faint traces' of what remains of distant pasts.

The randomness of history is freed from 'making sense' and returns, divested of all its explanatory and ideological costumes, as the faint and barely perceptible trace it really is.

As you clamber over the roots and rocks, you cannot mistake the walls of The Old Grotto. This time you really have found it! Something you may have read about in unreliable books or whispered about in pubs. The faint trace of ancient culture concentrated!

The storytellers and romantic poets may roar in grand metaphors, parading their intimacy with the old places, but theirs is a modern, eighteenth-century art, compared to what you are feeling now. For the old ones are here in their faint traces, their spilling springs and dentistry, their mermaid dives and vanishings through stone; they welcome those who engage humbly and reservedly and not as if they, the old ones, are savages who require shouting at.

So, intuit, don't roar; let the old ones reply softly; their lives may have been hard, but they are far away. In your first transformation, rising from the darkness of the well, you could speak to your true self; now here, after a second transformation, rising from light and nothingness-that-is-not-even-nothingness, you can speak gently to everything else; and

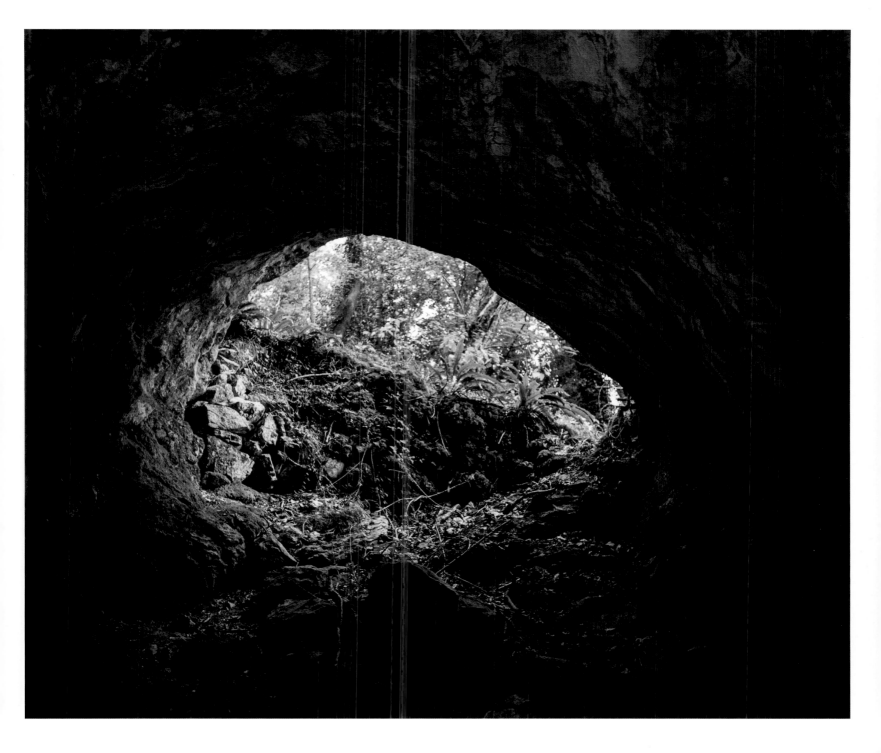

everything else–terrifyingly–replies.

Feel your life doubled by your embrace of darkness without darkness, nothingness less than nothingness. Awaken to connections and obligations and missions dormant for aeons. The hyenas that lived here, thousands of years ago, whose teeth were found here in their tens of thousands, suddenly return for you in a whirling mass of fur. Watch as the circling beasts with flashing jaws manifest, attend carefully to their cries and growls, and when you are ready, enter their circle. Move with them, race with them, chase with them, snap with them, re-wild yourself, rotate with the pack! If you feel the giddiness of confusion, give in to it, let your seriousness and goodness slip away, go with the pack! Only when you are exhausted, step away to the back wall.

Give reverence to the distant past, offer a profligate love, revere the connection-without-connection; your obligation to that which owes you absolutely nothing. To which you owe everything: the past!

When you are ready, in light walk back towards light, wade through the circling teeth and fur and step out, over the ankle-breaking rocks of the broken chapel. Pause for a moment. Consider a besotted medieval congregation gathering here, half-secretly, in their cave-chapel, protected by monks who understood, honouring the local magic of female saints of cavities, water martyrs and field goddesses who conjured streams from rocks and excavated light from caves, until the authorities threw down their walls–then step out into the flat grassy floor of the green valley.

Ahead of you, on the far side of a long, wide, green field, a few red cows munching on the grass, is the Great Hill, its crown obscured by a clumpy hat of trees.

Your rebirth is not a simple return to daylight, but a handing over by the tentacles of the cave to the tentacles of the valley.

What happens next? ❖

DAY 18

The Way To the Earthworks and Unpredictable Connections

FROM THE MOUTH OF THE CAVE, you head directly towards the Great Hill. At last!

Approach it warily; there is an opening here to older ways.

Your attempts to climb are at first thwarted; the lanes lead you away from any straight path to the summit. Persist. After a while, despite your frustration, you realise that you are physically circling the hill while imagining what is at its centre; the combination of these two motions, one physical and one mental, conspires to draw the whole of you into a spiral; free your thinking to curl around the hill and wind towards its summit.

Think everything in curling thoughts along the spiral. Take a moment without this book. Put it down. Let things spiral up and down inside and outside you.

Spiral-thinking brings you onto a bending path that winds up the side of the hill, a tall hedge on each side, as though you are climbing through a dappled yellow, red, green and brown serpent. Subject to the acids of the snake's innards your focus sharpens like the tips of fangs.

As you approach that part of the hill where Iron Age earthworks are hidden beneath the trees, there are gaps in the hedges. You can see all along the valleys to the moor with its granite tors.

Honour what you see on the hill: offer it an absurd love, without need for a logical explanation or self-interested exchange; offer an extravagant love and extreme submission to the being of the immediate world. Imagine the intense feelings of everyday directly worshipping the things to hand – a tree, a stream, a rocky outcrop – without any mediating theology, no tales of a Great Architect or an Invisible Creator.

Instead, stand face to 'face' with sylvan gods, place your hand in the wet race of a flowing spirit, touch with careful fingertips the barky skin of a dryad. This is not a reassuring worship; these things do not promise redemption, but a connection that will take you into unpredictable relationships. Such reverencing as this has little if any product, nothing is exchanged or gained or assuaged. Be generous, even wasteful, with your devotion; be unique, untransportable and careful. Savour the spirit of here, the untradeable and unrepeatable genius loci.

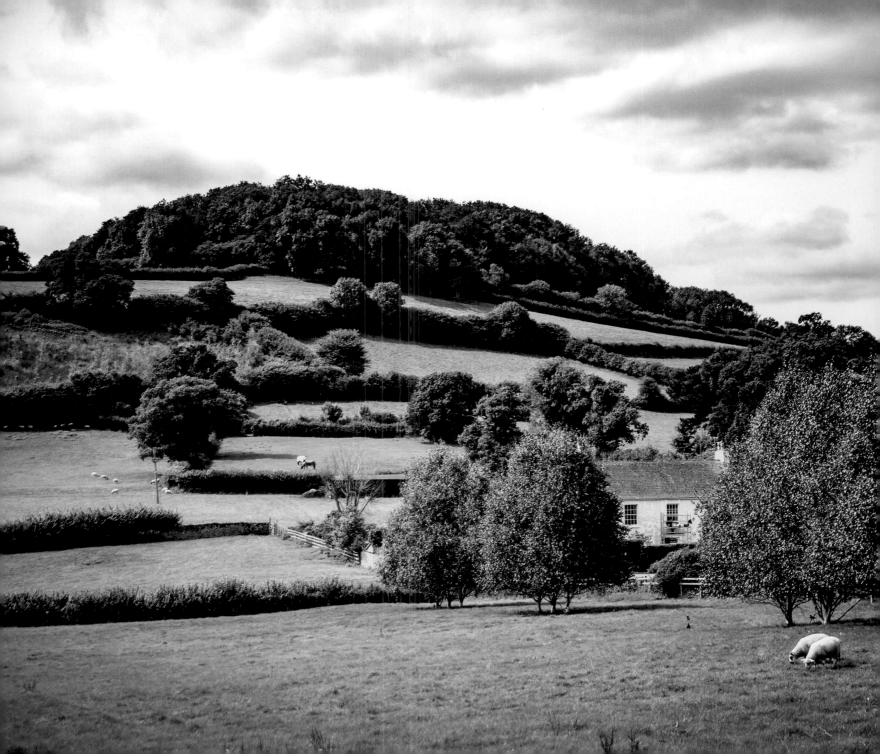

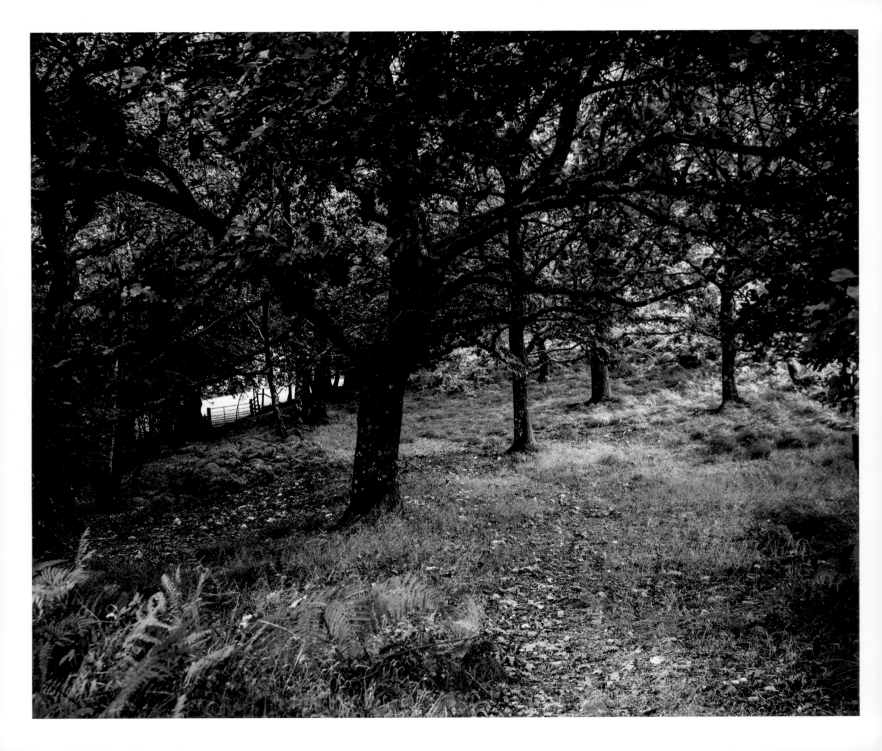

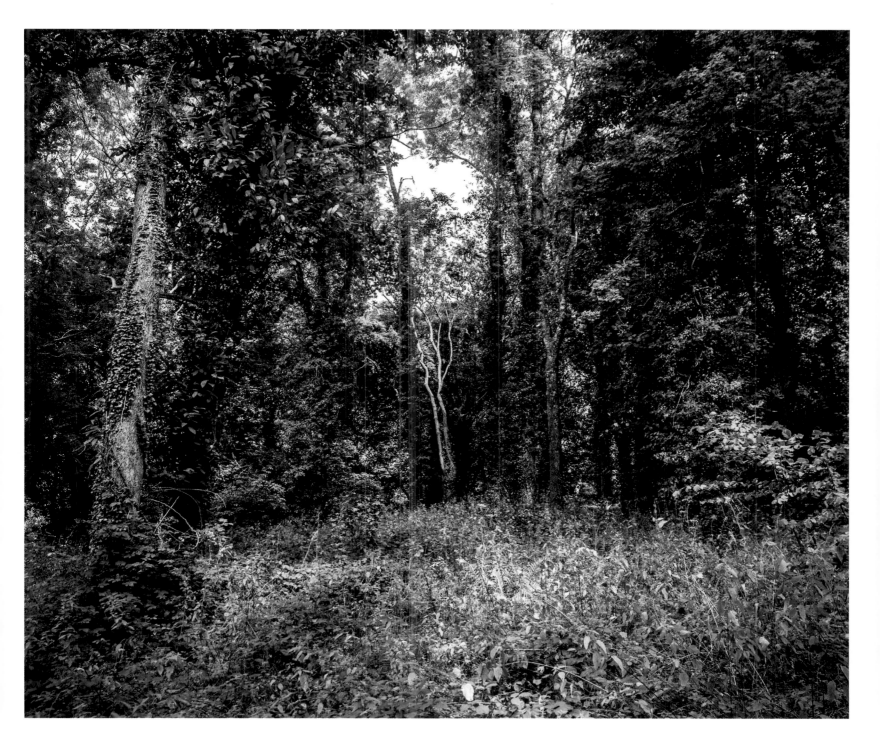

The Summit; From Your Own Mystery to a Bigger One

Climb over the stile and onto the crown of the Great Hill. It is covered by a canopy of mature trees. Although sheltered from the sky by the giant boughs and covers of leaves, there is still plenty of light for you to make out shapes in the ground. At first sight, they look like the ditches and earthen walls of an ancient military fort, but as you walk along the bottom of these passages you are confused. Parts of the 'walls' are clearly indefensible. These are not the shapes of defensive rings that our war-mongering culture has taught us to assume they are. This is a long winding entrance way, a curved hall for extended welcome and returning gaze. This is not a place for keeping out; but of folding a visitor in; a passage of special meetings, negotiations and overseeing. Feel the shadowy presence of past residents.

The sides of the ditches are raked, places where visitors can stop and listen to storytellers and hear announcements of news. The earth walls are raised high so the residents can show themselves to their guests, place notched wooden posts that tell a story along the way, negotiate with those they are suspicious of, talk before fight, meet by gaze before coming face to face and toe to toe.

You are in a kind of space you have not been in before. An architecture of generosity.

As you complete the uneven spiral around the Great Hill, you enter an even older place within the ancient earthworks: two rock and soil mounds on the crest. Approach them carefully; just as you cannot understand the feelings and gestures of the people who, by their architecture, have welcomed you in, they could not understand what those who were ancient to them had left behind a thousand years before; yet they reverenced their remains. In this way, time loops, not always

by knowing more or understanding particularly deeply, but by recognising and reverencing mysteries.

If you reverence the enduring of things, then the reverencing of things will endure.

Choose one of the great trees that now grounds itself on the old ones' mounds. Sit with your back to its trunk. Lean into the old tree and let your thoughts sink through its roots into what survives of the distant old ones. Claim no special relation to them, except that you share with them a prospect of de-composing and dispersal to the earth.

Consider the winding paths and spirals you have taken to get here, consider the heart and centre and grave you have reached, listen for indecipherable voices in the winds.

You have arrived.

There is not much else to learn.

Like all of the holy of holies, all of the mysticisms and religions—this is their shared dirty secret—at their heart is an empty chapel, a holy silence, a lack of explanation and the advice that you probably have to discover the truth for yourself.

The rest is inscrutable; if it means anything it is a healthy encouragement to keep at least some part of yourself unknown. Even to yourself. This is the secret knowledge that 'know thyself' should never be taken to extremes, that you should always allow some indescribable part of yourself to remain vigorously enigmatic, and reverence the cosmos in the same way, leaving the mysteries free to work their rough, inarticulate and lustful generation of life.

Sitting against the tree, think down through the roots of yourself until you have sunk to where the edge of your unknowable resides. Wait at its border, don't try to describe the place to yourself, but be with it, circle it, move along its ditches, acknowledge it and let it be. ❖

DAY 19

The Basalt in the Hill and the Basalt's Memory

YOU LEAVE THE HILL; it is not the same hill, it is not the same you, it is not the same world. On the edge of the Iron Age earthworks, a gap in the dark trees frames the sunlit valley.

The world floods back into you. Look back.

Close your eyes. See where you have walked.

When you open your eyes, the Great Hill, formed of basalt, what remains of an eruption of lava through the ancient ocean bed and its reaction with sea water, raises its summit like the bulbous head of a massive cephalopod, its arms take the form of lanes and lines of trees and hedges and straggling homesteads. You are enfolded. There is no god, there is no great secret, but there is cosmos and it loves, holds and sustains every part of you.

Love it back.

As you walk down a green arm, see each place, person and thing anew, separate but connected, a squid within you and a squid without you, each a bloom of interwoven possibilities.

Walking back to the station on the coast to catch the return train, you pass through a vale without depths, where there are few people, where nothing much seems to be happening. Pass by a derelict caravan turning green with moss, amble through a colonnade of ancient and giant chestnut trees, their grey twisted pillars bearing huge canopies of striking green. Finally, walk through a verdant 'everglades'. Bursting up from between a tarmac footpath and a junkyard, it is a green wonderland that is deep and alive and thickening. To each place, whether abject or grove-like, open your body and emotions, as if meeting a kindred spirit for the first time.

Returning is never going back to the same place. ❖

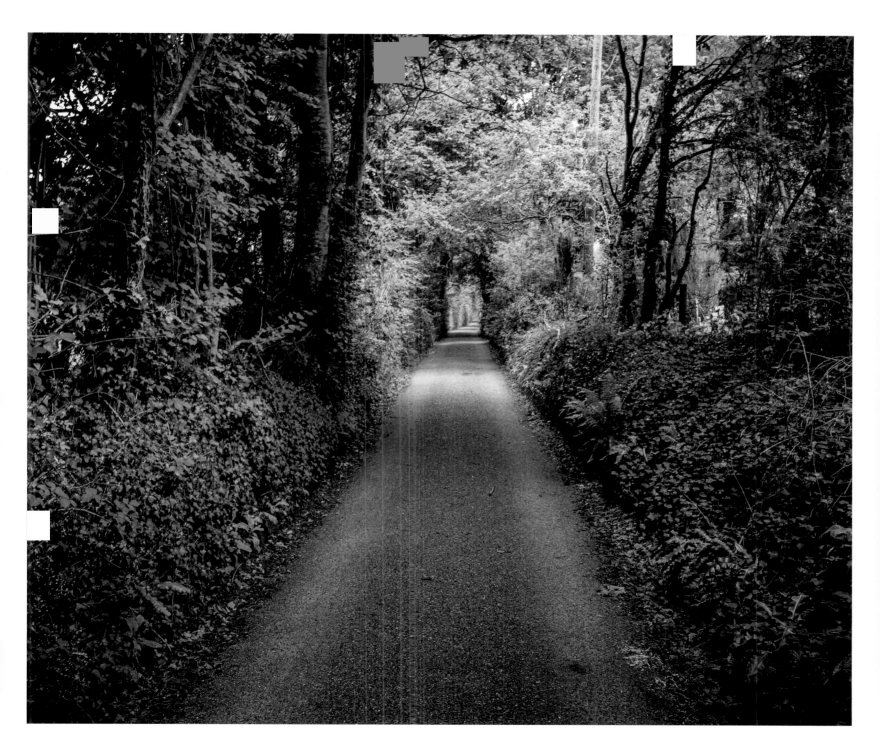

The journey is never over. Even a virtual one. Ideas and imaginations are as ancient and lively as galaxies. They do not fully die, but move the goal posts and the playing field; cannily changing registers and keys and scales. Energy is constant; but all the time it is tied up in new ways. Yet "everything changes" is not enough; there is always the need to have something sharper and more principled that can play around the plateau of vitality and excitement we hope you have found here. The agent of that sharpness is you, and the next bit we cannot help you with. We have indulged ourselves in sharing our journey, hopefully with some generosity, but that only goes so far. The last few pages of our pilgrimage are a preparation for now; the invitation, not from us but something far more generous, is to make your own way. The best we can do now is to admit our limitations and wish you well – and shocks, encounters, transgressions and transformations – on whatever road you find.

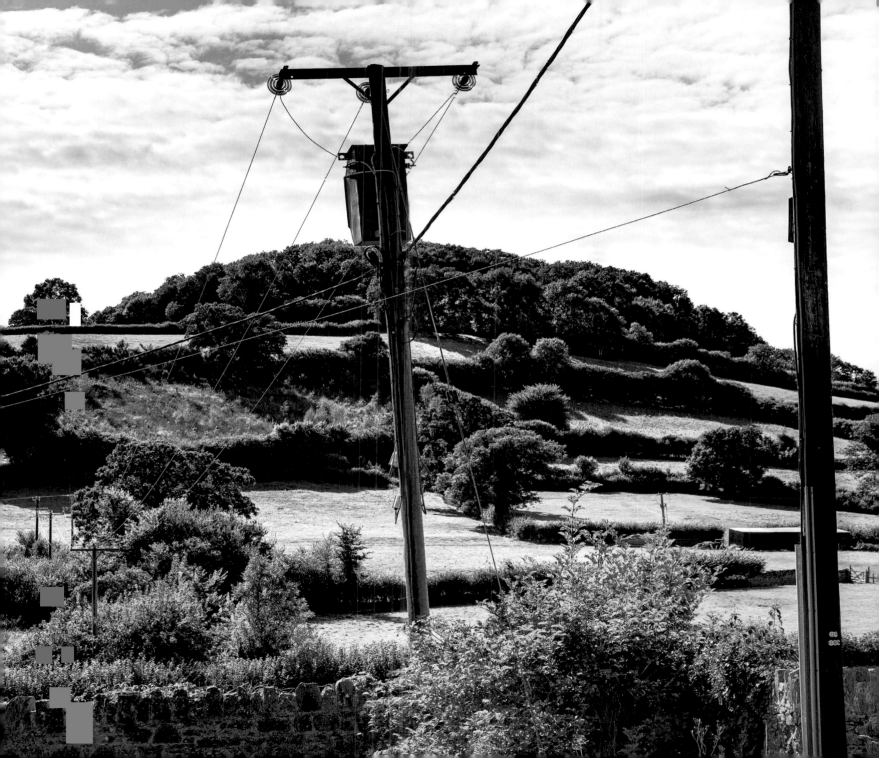